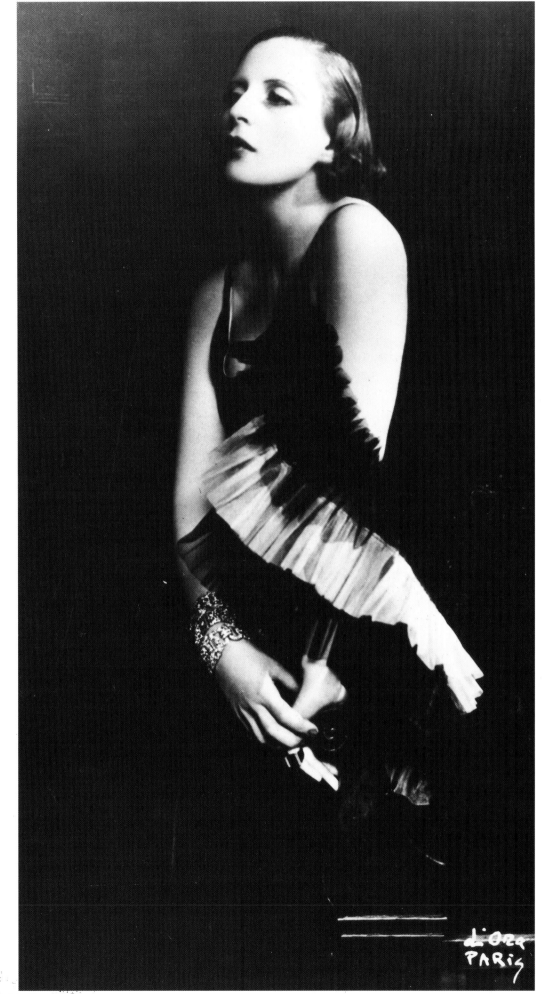

Gilles Néret

Tamara
de Lempicka

1898–1980

Benedikt Taschen

FRONT COVER:
Detail from: *Autoportrait (Tamara in the Green Bugatti)*, 1925
Oil on wood, 35 x 26 cm
Private collection
(see illus. p. 6)

FRONTISPIECE:
Tamara de Lempicka in the 1930s
Photo: Cecil Beaton

BACK COVER:
Detail from: Tamara de Lempicka in the 1930s
Photo: Cecil Beaton

**This book was printed on 100% chlorine-free bleached
paper in accordance with the TCF standard.**

© 1993 Benedikt Taschen Verlag GmbH
Hohenzollernring 53, D-50672 Köln
© 1991 Baroness Kizette de Lempicka-Foxhall, Houston
Edited and produced by Sally Bald, Cologne
Cover design by Angelika Muthesius, Cologne
English translation by Michael Scuffil, Leverkusen
Printed by Druckhaus Cramer GmbH, Greven
Printed in Germany
ISBN 3-8228-0558-0
GB

Contents

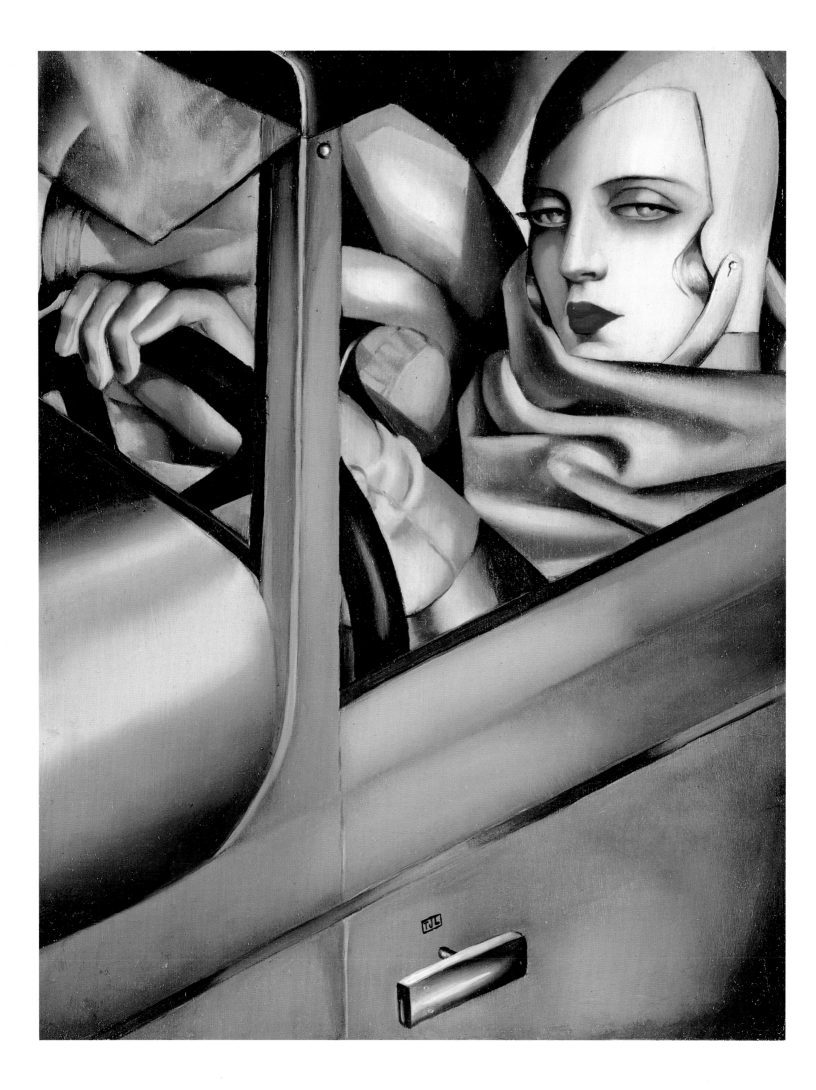

Cool, disconcerting beauty: this woman is free ...

Ambiguous, for sure. Free, without a doubt. A legend, quite certainly. Tamara de Lempicka, *la belle Polonaise*, the star of the interwar years, had all that it took to symbolize her era. The elite of her era, to be sure, those who frequented the Ritz in Paris or the Grand Hotel in Monte Carlo, what today we should call the jet-set.

As recently as 1978, the "New York Times" was still calling her the "steely-eyed goddess of the automobile age". And indeed, her most famous painting, a self-portrait entitled *Autoportrait* or *Tamara in the Green Bugatti* (illus. p. 6), reveals something of the relationship Tamara had with machines, be they of steel or flesh and blood ...

Woman-automobile, automobile-woman ... where does one begin and the other end? What sort of relationships do they have with each other and with men? It is difficult to be sure. Just to pose the question is to raise the issue of the whole ambivalence to which Tamara de Lempicka's work bears witness in such abundance. And always, one comes up against that sense of displacement which results when, having thought one has solved the mystery, one finds one has to start from the beginning all over again: the initial data were simply wrong. Thus in reality Tamara never possessed a green Bugatti, but only a little bright yellow Renault. What counts, she said, is that "I was always dressed like the car, and the car like me".[1]

One imagines Tamara as the unchallenged star of a fashion contest stepping out of the car and presenting herself to a jury whose members could include the Great Gatsby, Hemingway or Coco Chanel, and then in an elegantly superior attitude – one hand placed casually upon the bonnet – posing in front of the vehicle. Perfect harmony between woman and object, the one supplied with the name of a great couturier, the other with the emblem of its maker and designer. Customarily we expect an exchange of roles between the two elements of this tableau: the woman becomes an object, in a society like ours based on the concept of possessions, while the automobile appears as the projection of the virile potency of the man who created it. The underlying symbolism presses itself upon one in no uncertain terms: by placing her hand upon the bonnet, beneath

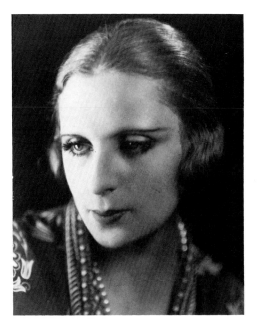

Tamara de Lempicka in the 1930s

Autoportrait (Tamara in the Green Bugatti), 1925
Oil on wood, 35 × 26 cm
Private collection

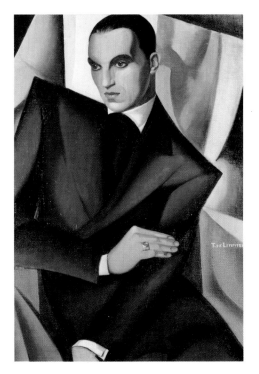

Portrait of Marquis Sommi, 1925
Oil on canvas, 105 × 73 cm
Private collection

which 400 horse-power is just waiting to be ignited, the woman – a graceful apparition in her chic Twenties costume – is proclaiming, in a sense, that she is subordinating herself to a force which finds one of its most elemental forms of expression in the impetuousness of the motor.

Such an interpretation, particularly in Tamara's case, overlooks the fact that the car is also a symbol of women's emancipation. The machine is namely in the power of its mistress, who can impose her will upon it, spur it on to crazy feats of performance, turn it into a docile slave. A Tamara de Lempicka takes it completely for granted to seize upon a symbol of strength, represented by the car's engine, and to re-deploy it in such a manner as to make it work exclusively to her advantage.

From this we can draw the conclusion that the relationship between our heroine and not only the car, but also men, and women too, is suspect at the very least. An attitude never totally free from a certain horror, which can be glimpsed behind the seemingly immaculate façade. Are the others, she asks herself, irrespective of their sex or their species, are they allies or rivals? Can one not change from feminine to masculine depending on whether one is an accomplice or a chauffeuse, a lover or a mistress, depending on one's own degree of femininity ... or masculinity? After all, every human being, man or woman, is a subtle mixture of the two.

The life and work of Tamara de Lempicka are impregnated by this subtle mixture. They are also a reflection of it, as in a distorting mirror. It is not just by chance that her "Auto-Portrait" portrays her with an automobile. The latter functions as a piece of adored machinery, as a simile of love, capable on both counts of bringing about a salutary change in the soul of a mortal being.

This ambivalence, halfway between a mathematical formula and a magic spell – Tamara played upon it to excess. But beware: like all the famous heroines – from Hadaly in Villiers de L'Isle-Adam's novel "L'Eve future", to E.T.A. Hoffmann's Coppelia, from Descartes' "Francine" (that stupendous automation) to the "bachelor machines" dear to the hearts of the surrealists – Tamara is also capable of strangling her rival or of dispatching the hero to the same grisly end as Prometheus suffered. One does not rob the gods of the fire of knowledge or of science with impunity, just to breathe life into voluptuous fairies, disquieting lords whom one loves and paints.

Docile mistress or pretty strumpet, obedient pet or wild beast red in tooth and claw, Tamara, like her automobile double, can lead her lovers, male or female, her creature, her master or her mistress, towards ecstasy, escape, liberty, oblivion ... or else against a tree, to the torments of hell.

It was not unusual, for example, for another woman, fascinated by this symbiosis of lady-driver and automobile, to remark to her: "You look so wonderful in your car that I'd love to make your acquaintance ..."[2]

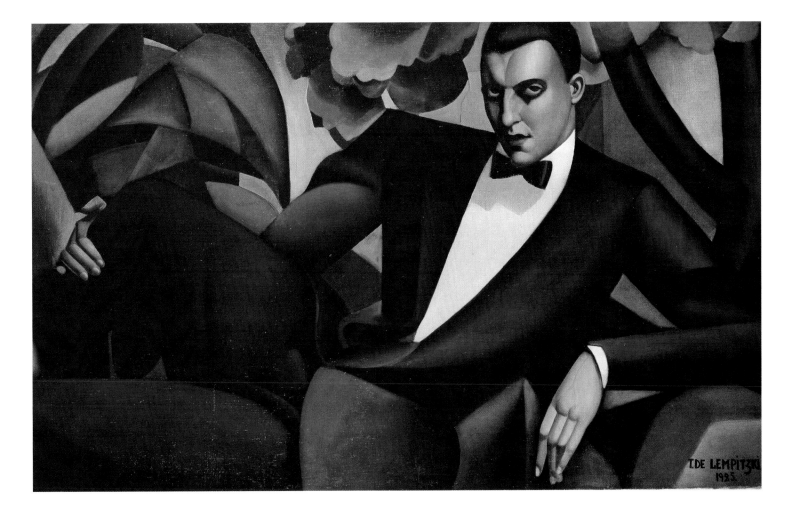

This, incidentally, was just what happened on the occasion of her first meeting with the editress of the German fashion journal "Die Dame", who commissioned the "Auto-Portrait" for the cover-page of her magazine. As a result, the painting achieved fame overnight, hailed as the image of the modern woman. As time went by, it came to be seen as the perfect portrait of the age. From then on, the artist was identified with machinery. The Hollywood Theater even used the picture as the poster for the play "Tamara: a Living Movie". In "Das Magazin" Lempicka was compared to a beautiful Brunhilde: she and her car embodied the double aspect of a woman at once voluptuous and superior. As late as 1974, "Auto-Journal" hailed *Tamara in the Green Bugatti* as the true portrait of the emancipated woman who knows how to get what she wants. "She is wearing gloves, and a helmet. She is inaccessible, a cool, disconcerting beauty, behind which a formidable being can be glimpsed – this woman is free!"[3]

Portrait of the Marquis d'Afflitto, 1925
Oil on canvas, 82 × 130 cm
Private collection

"I live on the fringe of society, and the rules of normal society have no currency for those on the fringe."

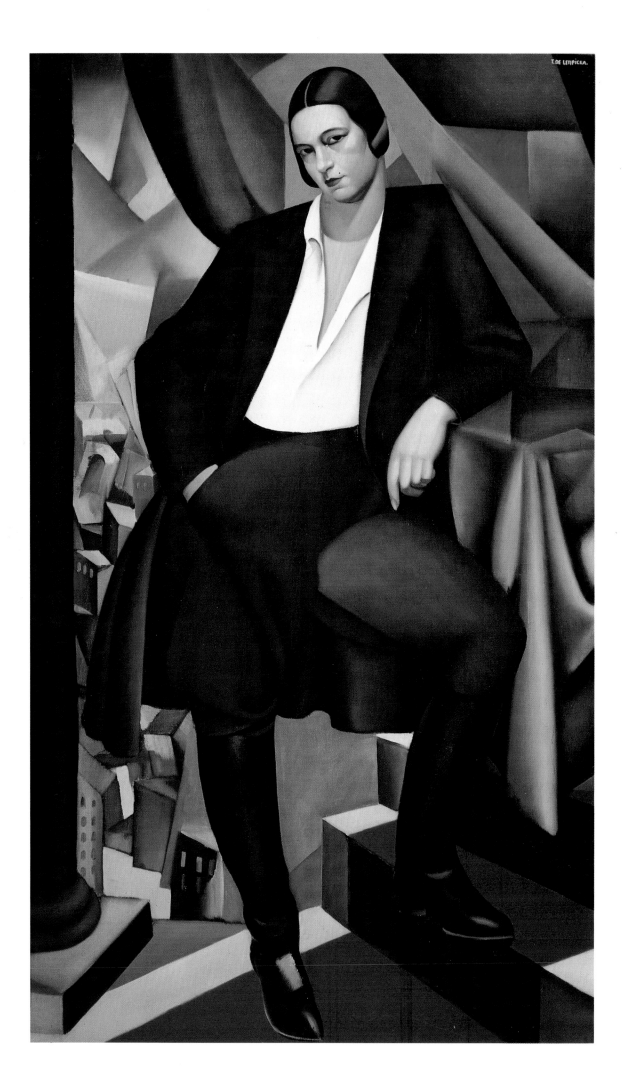

La belle Polonaise

"Sic transit gloria ..." notes Giancarlo Marmori in his introduction to the imposing volume which Franco Maria Ricci was to dedicate to "la belle Polonaise", to this "tableau vivant": "when in July 1972 the Galerie du Luxembourg in Paris put on a retrospective of the works of Tamara de Lempicka, no one knew any more, no one remembered, this painter who was in vogue at the same time as the couturier Paquin, this beauty with the strange, probably Slavonic name, sounding as if it had been borrowed from some sophisticated repertoire of Art Nouveau pseudonyms."[4]

It must be conceded that the biography of Tamara de Lempicka, née Gorska, is not exactly bulging with facts. Like Greta Garbo, with whom she was acquainted, this star of Art Deco painting did everything she could to cover her tracks, leaving behind but few biographical cast-offs in an abundance of mysterious silence. Carefully selected cast-offs, mark you, chosen to promote her own image, like the trailer for some serial. Sometimes she calls herself Lempicka, sometimes Baroness Kuffner, the name acquired on her second marriage, to the Hungarian baron Raoul Kuffner. She appeared from nowhere in Paris in 1923, at which time she was said to be sixteen. A brief calculation will therefore establish that she was born around 1906 or 1907. But she acknowledged on another occasion having been first married in 1916. At the age of ten? Was she born in Warsaw? No one knows. What is known is that she arrived from Russia, a fugitive from the Revolution, in the company of her first husband, one Lempicki.

She lived the life of the Bohemian Montparnasse, albeit on the "rich" fringe, in Auteuil. For an émigré, she was of a fairly revolutionary turn of mind, but perhaps a little after the fashion of Marie Antoinette, who recommended that people eat cake if they had no bread. She was, to use the vogue word of the twenties, "smart".

Two anecdotes quoted by Giancarlo Marmori illustrate this state of mind, or rather this life-style. The first shows her, during a period when she was not exactly rolling in money, buying half a dozen "religieuses" (a kind of pastry filled with cream) from a patisserie for the purpose of painting them as a still-life. But the artist is so

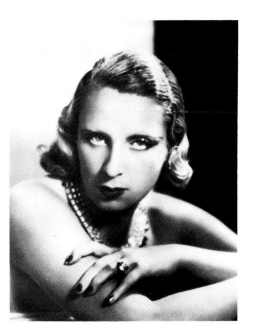

Tamara de Lempicka in the 1930s

Portrait of the Duchess de la Salle, 1925
Oil on canvas, 161 × 96 cm
Private collection

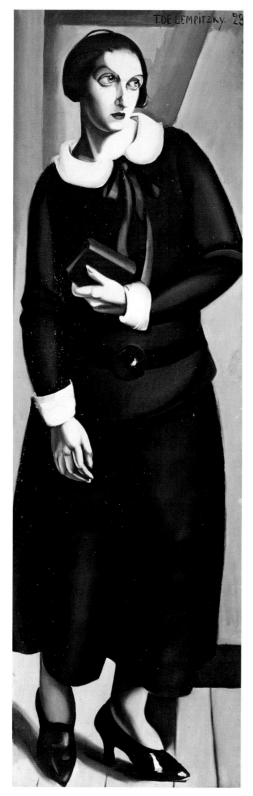

Woman in Black Dress, 1923
Oil on canvas, 195 × 60 cm
Private collection

famished that she devours her still-life on the spot. Just like Jean Cocteau, whom she was to meet on numerous occasions in this artistic circle, Tamara could resist everything except temptation.

The second anecdote takes place at night, in the artists' cafe "La Coupole" in the middle of Montparnasse, where she is in the company of the futurist F.T. Marinetti. After much quaffing, along with a speech by the author of the Italian futurists' "Manifesto", which reaches its climax amid cries of "Burn down the Louvre!", the whole group of poets and artists, somewhat the worse for drink, decide to go and do just that: set fire to the symbol of the past. But alas, the car, Tamara's already legendary car, which was to take this fine company thither, had disappeared. The adventure comes to a banal end in the police station, with Tamara reporting the theft of a car.

In a certain sense Tamara de Lempicka was a dandy, comparable to Beau Brummell or, more appropriately, to Countess Greffulhe, who served as the model for Marcel Proust's Duchesse de Guermantes. She had that certain something which made her manner so delicious, so inimitable, so assured that her distinguished superiority imposed itself without any prompting. Nothing illustrates this dominating attitude and its devastating effects on a man better than her very curious relationship (verging on the burlesque) with Gabriele d'Annunzio. More of this later; she herself summed it up to Franco Maria Ricci thus: "I was a beautiful young woman, and there before me was this old dwarf in uniform."[5]

A further parallel with Brummell – apart from the fact that one should not confuse dandyism with eccentricity – consists in the fact that the whole mystery of the one as of the other resided in this intangible thing that made one of them the prince of his age, the other the star of her period, while both have left only fragmentary traces in historical memory.

This dandyism is also manifested in the decor with which she quite deliberately surrounded herself. Thus from 1933 until her departure for the United States, while at the pinnacle of her career, she lodged in a three-storey townhouse in the rue Méchain (illus. pp. 37, 44, 68 below) which reflected her tastes precisely, and which Marmori described thus: "The chronicles of the period are positively overflowing with enthusiastic descriptions of the up-to-date decor and structures of this house, designed by Mallet-Stevens, the architect of the Noailles and of Poiret; they speak of grey tones, of chrome plating, of an American bar, of wood panels, of beige wallpapers. According to one of these chroniclers, the artist's bedroom is bathed in a sub-marine green. Here the painter received the cream of Parisian society, and extensive reports of these "parties" appeared in the newspapers. Thus in 1937 she received the ambassadors of Greece and Peru, van Dongen and Princess Gagarin, Kisling and Dr. Voronov (who had proposed marriage to her, and collected her paintings, G.N.), the Duchess of Villarosa and Lady Chamber-

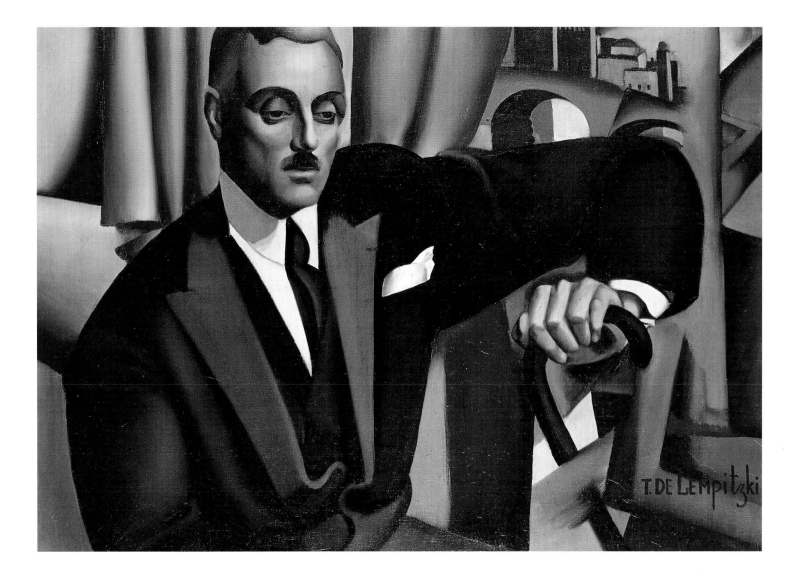

Portrait of Prince Eristoff, 1925
Oil on canvas, 65 × 92 cm
Private collection

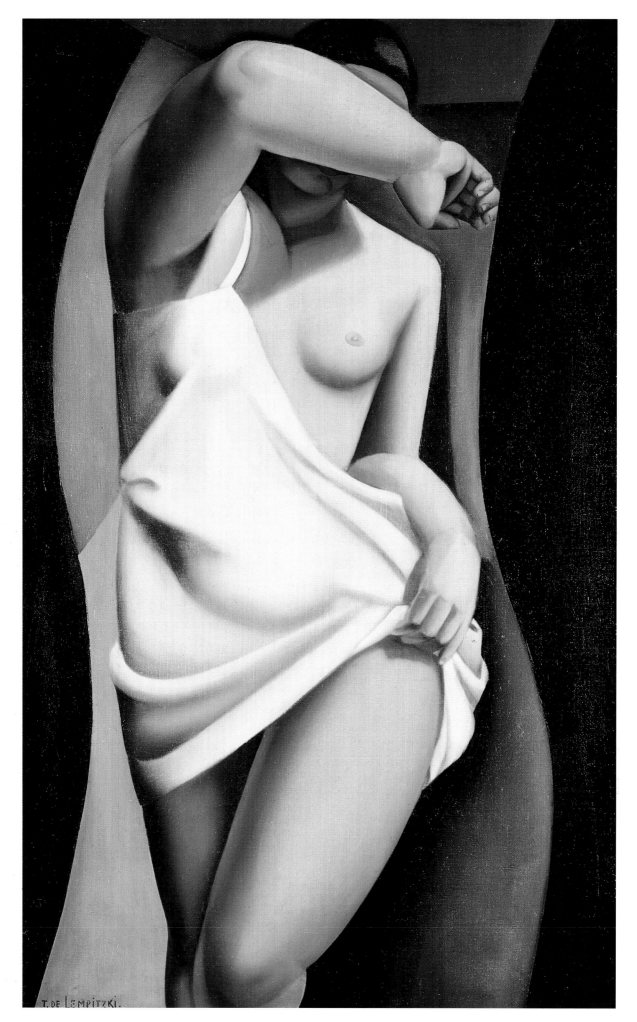

T. DE LEMPITZKI.

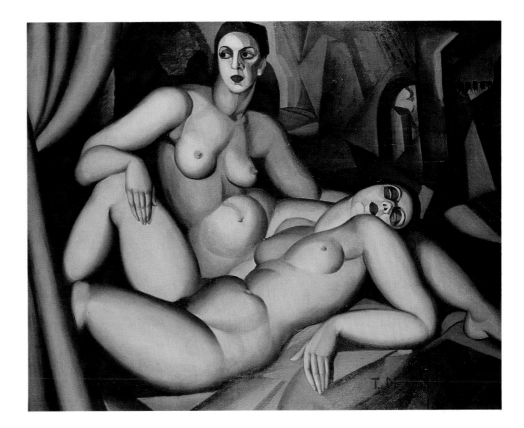

The Two Friends, 1923
Oil on canvas, 130 × 160 cm
Geneva, Musée d'Art Moderne, Petit Palais

The Model, 1925
Oil on canvas, 116 × 73 cm
Private collection

lain, her teacher André Lhote and the Clemenceaus. The artist's
beauty and elegance and renown formed the centrepoint of a large,
fluctuating circle; around her, personalities revolved like celestial
bodies – large and small, brilliant or extinct. A number of reporters
fell into ecstasy on seeing her (and d'Annunzio, for his part, defined
her as "the woman of gold"). They were carried away by her hands,
her hair, her wardrobe. To one Fernand Vallon, who visited her at
the time of her *Andromeda* (illus. p. 27), she appeared "in ecclesias-
tical purple, with emeralds as deep as lakes: blonde, sumptuously
blonde, with 'exquisite hands, adorned with blood-red fingernails'
she would move aside large canvasses 'reminiscent of grey velvet,
like her wallpapers.' " A reporter for the "Monterey Herald", who
was granted an interview in 1941, had to catch his breath when con-
fronted with the apparition of this 'tall, thin something', with 'red-
gold hair falling luxuriantly over her shoulders'. Everyone was
amazed, and had to fall back on hyberbole, like a certain nameless
commentator in the magazine "These Women", who had the oppor-
tunity to see her stretched out on a heavenly divan, in a robe of
white satin, decorated, so we are told, with 'woolly, white marabou
feathers'; the same chronicler goes on to remark that Tamara is tall
(which is true), as well as being slender and smooth, but provided in
the appropriate places with the necessary curves."[6]

This mood was still reflected by Franco Maria Ricci, who con-
fesses, full of nostalgia: "One day, in her suite in the Grand Hotel,
Tamara absent-mindedly crossed her legs, and as in a film, I had a
glimpse of those involuntary seduction fantasies in the manner of a
nineteen-thirties movie."[7]

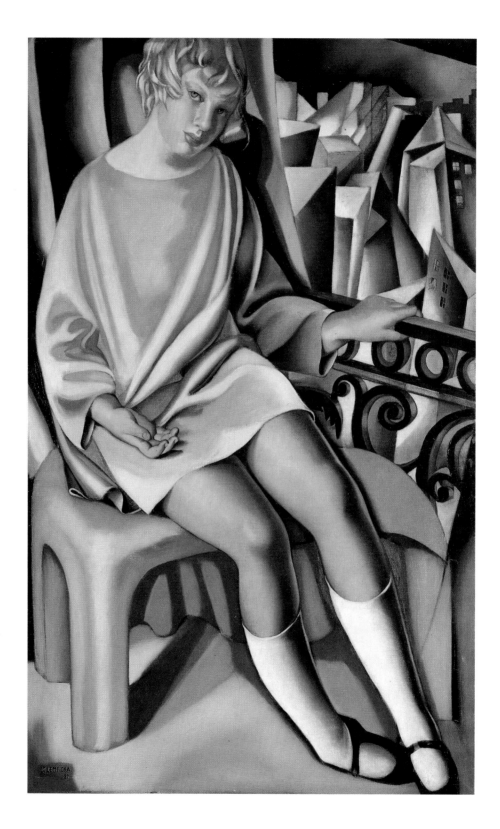

Kizette on the Balcony, 1927
Oil on canvas, 126 × 82 cm
Paris, Musée National d'Art Moderne

Tamara received her first painting lessons from Maurice Denis at the Académie Ranson. Maurice Denis was the painter who caused such a stir in his day with a statement that both impressed itself on his pupils and brought him lasting celebrity: It must be remembered that a painting is essentially not so much a war-horse, a naked woman or some story or other, as a plain surface covered with paint in a particular arrangement.

In spite of this "modern" position, Maurice Denis remained a purely decorative painter his whole life long; his style was archaic, post-symbolist, even when he was trying to "renew" his subject, something he believed he was doing, for example, by substituting, in his painting *Les Muses*, visibly bourgeois figures, strolling in the Bois de Boulogne, for the deities of ancient Greece customary in the genre until then. At this period even someone like Eugène Poughéon would not shrink from placing "Venuses" and "Pegasuses" in the surroundings of the Jockey Club, while his rival Emile Aubry managed to seat a rococo Liberty vamp astride the back of a centaur. Even so, Maurice Denis was a hard taskmaster and a methodical teacher; the patient apprenticeship which Tamara absolved under his eye enabled her later to create immaculately structured pictures.

Her definitive stamp, however, Tamara received from the instruction she went on to receive from André Lhote: painter, decorator, critic, art-teacher, theoretician – activities which he himself found difficulty in reconciling, and which often enough prevented him from realizing the subtle syntheses of his inspiration. André Lhote was the inventor of a revised and corrected cubism, a "safe" cubism using "bourgeois" colours, a so-called synthetic cubism which Tamara took up immediately. In other words, it was a question of reconciling the iconography of the Salons (or, shall we say, of the academicians and other hacks) with avant-garde cubist experiments of Braque, Juan Gris, or Picasso. In short, to place a variety of cubism (one had to move with the times, after all) at the service of the bourgeoisie, albeit an attenuated cubism, acceptable on the walls of a respectable household, and unlikely to frighten away the visitors. On the one hand, Lhote was of the opinion that what the impressionists had built up on pure colour must now be transferred to the level of form. On the other hand, the only thing that interested him about cubism was its rational, constructive aspect, which, in his opinion, allowed the phenomena of the natural world to be preserved in a painting, and the forms of objects to be left intact, a human body, for example, being an object like any other. This was what he called the "plastic metaphor", a metaphor which Tamara used time and again in her artistic output: in her harems populated by provocative idiots; in her nudes, which are also allegories of lasciviousness; or in her portraits characterized by the haughty expression typical of a certain caste. Of course the negative side of this procedure is that this kind of neo-cubism, robbed of its original strength, is in most

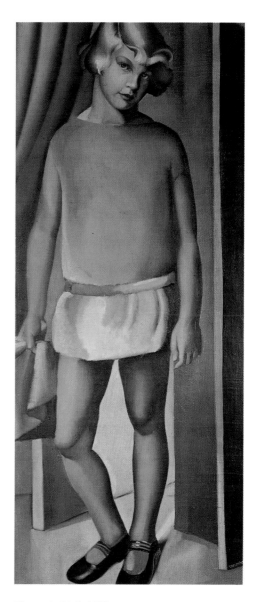

Kizette in Pink, 1927
Oil on canvas, 133 × 57 cm
Private collection

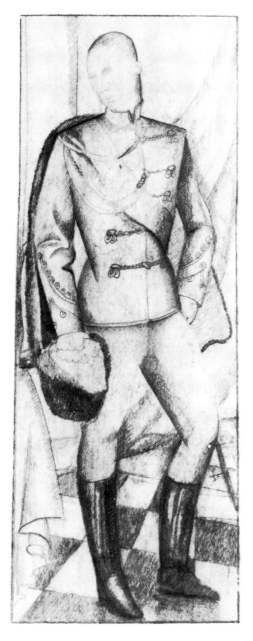

Sketch for *Portrait of H.I.H. the Grand Duke Gabriel,* 1927

Portrait of H.I.H. the Grand Duke Gabriel, 1927
Oil on canvas, 116 × 65 cm
Private collection

cases left with nothing more than the most superficial aspects of cubism as originally conceived. There is a penalty to be paid when one reduces the figures to the lowest common colour denominator just in order to satisfy the requirements of plasticity. This is to confuse academism with simplification of the picture. One could say that André Lhote confused cubism with geometrism without realizing that cubism implies a total questioning of the pictorial system created by the Renaissance.

This compromise style reached its high point in 1925, in the form of the celebrated "Exposition internationale des Arts Décoratifs et Industriels Modernes" in Paris. This exhibition really did present a remarkable unity of preoccupation and style in the various activities that contributed. Furniture, fashion and costume, ornament etc. – "Art Deco" – among whose worshippers Lhote was the chief, alongside La Fresnaye, Valmier and others – represented the official attempt at a synthesis of cubism on the one hand and a simple, stylized approach to design on the other.

So long live détente, long live joie de vivre, long live security. Tamara felt absolutely at home in this illustrious post-war society, which, somewhat disconcerted by the rise of the nouveaux riches, overwhelmed by the Bright Young People of the Roaring Twenties, could feel its resistance weakening. The new aristocracy of wealth, striving both for conspicuous consumption and for profitable investment opportunities, was beginning to scent out the profits that could be made from artistic infatuations, and sensed the speculative possibilities opening out in this field. Far-sighted art-dealers, striving to gain acceptance for a style not yet respectable, in the manner for example of Durand-Ruel for impressionism, or Kahnweiler for cubism, were already being displaced by greedy hard-nosed businessmen. Under their influence, and despite an initial repugnance, the bourgeoisie took up the cause of modern art, very conscious at the same time that it was an asset whose fortunes might well be on the up. There were enough artists prepared to deliver to order, and only too happy to have their works included in private collections. "Do you really like that?" "Oh, you get used to it, you know."

After all, one did have to establish a front against the Bolsheviks, against the "man with the dagger between his teeth". One had to move with the times. Today we would say: sterilize these forces and these creations, render them harmless, while at the same time "keepings one's cred".

Representational painting wasn't necessarily reactionary; even academism should be able to promote the development of art – but without revolutionizing it. Bonnard, Vuillard, Matisse – these were artists one could live with, after all. Why not retain those aspects of cubism or fauvism that were acceptable? The totalitarian regimes were even taking this doctrine to its logical conclusion, in Russia for example, by demanding socialist realism both in painting and in sculpture. It was what René Huyghe called "the return to appear-

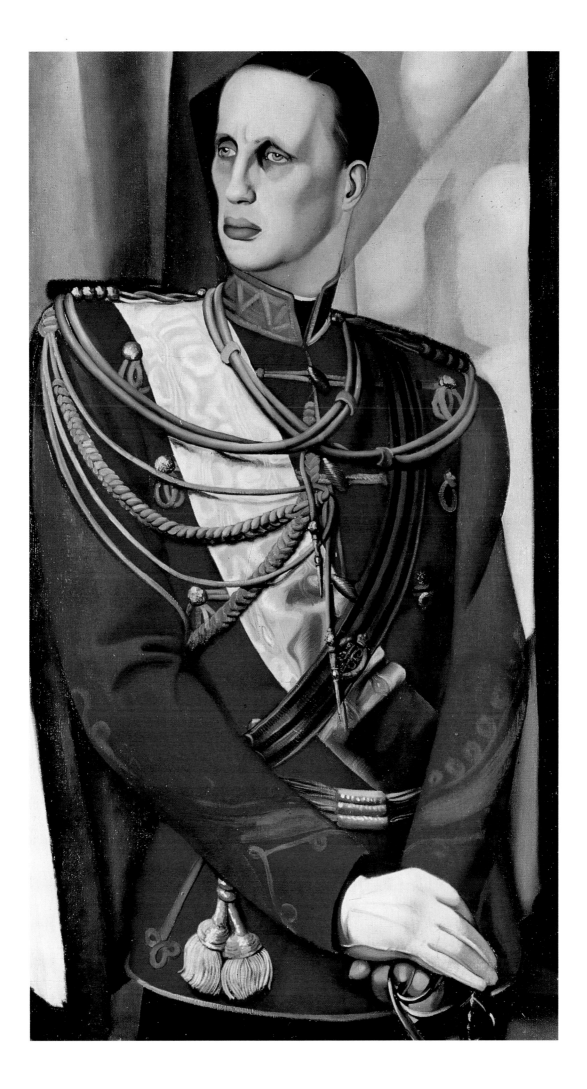

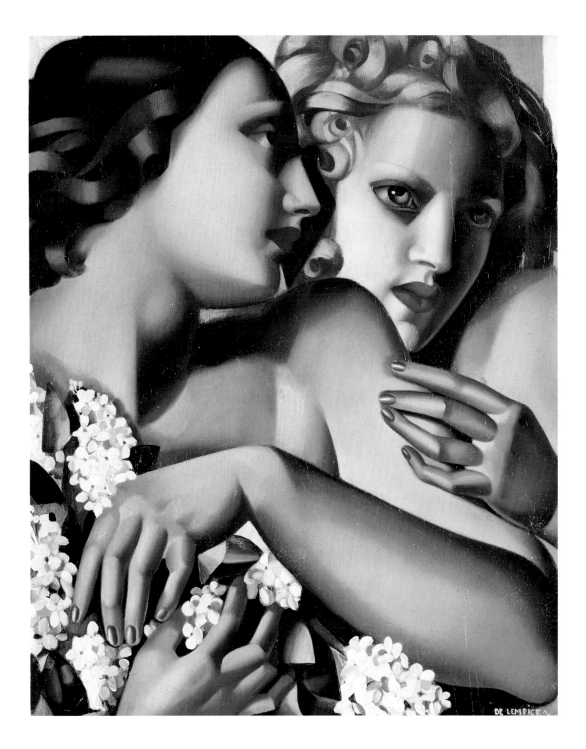

Spring, 1928
Oil on panel, 40 × 33 cm
Private collection

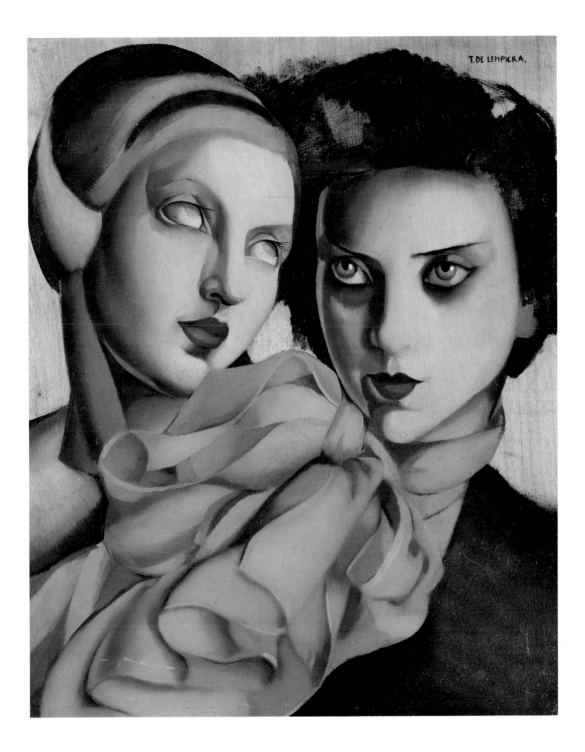

The Young Ladies, ca. 1927
Oil on wood, 41 × 33 cm
Private collection

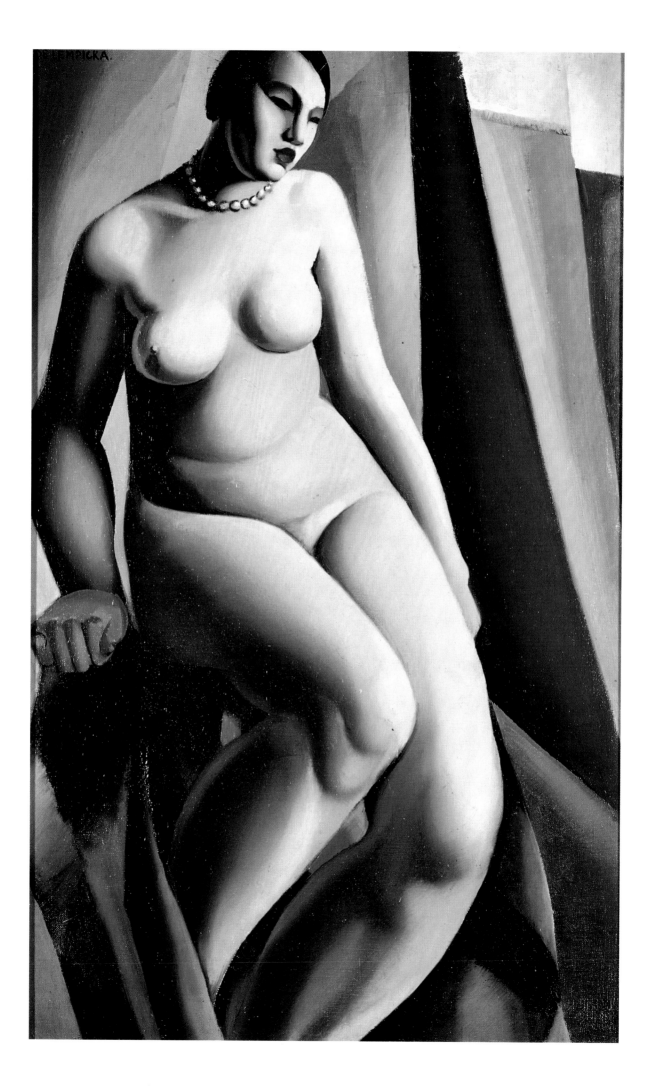

ances", as if life were coming into its own once more after the era of mass death and destruction.

This represented the official triumph of the style of the "artistes français", the academic regime. Modernist imitations were echoing, in a way, a certain neo-Ingrism, Tozzi was looking to Kisling. Ingres and his *The Turkish Bath* (illus. p. 34) – to which Tamara's picture *Beautiful Rafaela* (illus. p. 45) owes a great deal – were the objects of considerable veneration, and a number of painters then in fashion were spoken of as "cubo-ingrists". Woman as a subject was defended against the "massacre" perpetrated upon her by fauvism, by expressionism and by cubism. An appeal was made to French tradition, people rallied to the defence of "painting as craft", in other words a form of painting devoid of all cosmopolitan or intellectual pretensions, thus preparing the ground for a veritable witchhunt directed against "wogs", a trend which found its culmination in Adolf Hitler, the picture bonfires and the inauguration by Goebbels of the notorious exhibition of "degenerate art". The motto of the salons was: "do sound and tasteful work". The female nude, in Tamara's œuvre a frequent subject, as is well known, had a privileged position as the heritage of past generations and as the natural followup to classes in the academy. After all these horrors, at last a refuge in the salon!

The tone was set by Miklos, Poughéon, Emile Aubry, René Crevel and Fauconnet, who were promoting this style of decorative compromise. It was quickly reduced to a system and applied to all the aspects of the then-fashionable movement for applied arts, in such a way as to turn it into a new academicism itself. A contemporary critic and advocate of this trend discoursed in a pamphlet entitled "La Folie picturale" on the contrast between true art and "bolshevist" tainted art. "Meanwhile," he writes, "draughtsmanship has been subjected in many places to a silly sabotage campaign, which is no more than an excuse for ignorance, laziness and sloppiness. It is a transparent piece of specious nonsense to assert that distortion is an adequate and infallible means of enhancing expressiveness ... The whole drama can only be comprehended through verisimilitude of movement, facial expression, decor and colour. That is what an artist has to put into his work. But an expressionist or a surrealist finds it easier to use caricature and ugliness as a cop-out. And on top of this we are even expected to express our gratitude to him when he deigns to acknowledge that painting should attempt to signify something, or anything. What's the latest formula? 'Today's painting must not express feelings.' Indeed no! But then one might just as well look at a collection of butterflies or a carpet from Turkestan. If an art which claims to be 'alive' is reduced to such wretchedness, it's in a pretty bad way. If the mosaic artists of Byzantium or the fresco painters of our cathedrals allowed themselves to distort their subjects from time to time, then this was conditioned by the ligthing or the architecture. And with what intelligence they set

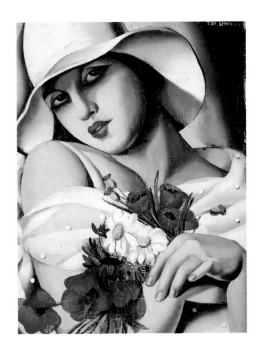

High Summer, 1928
Oil on wood, 35 × 27 cm
Private collection

Seated Nude, 1925
Oil on canvas, 61 × 38 cm
Private collection

23

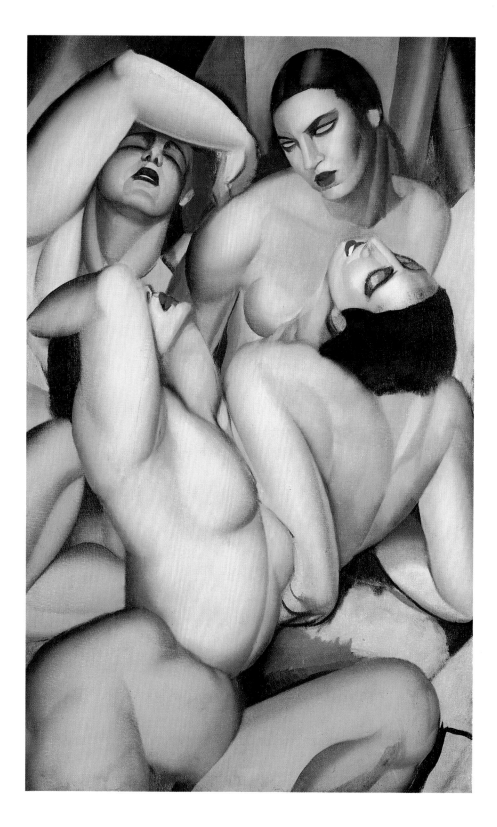

Group of Four Nudes, 1925
Oil on canvas, 130.8 × 81 cm
Private collection

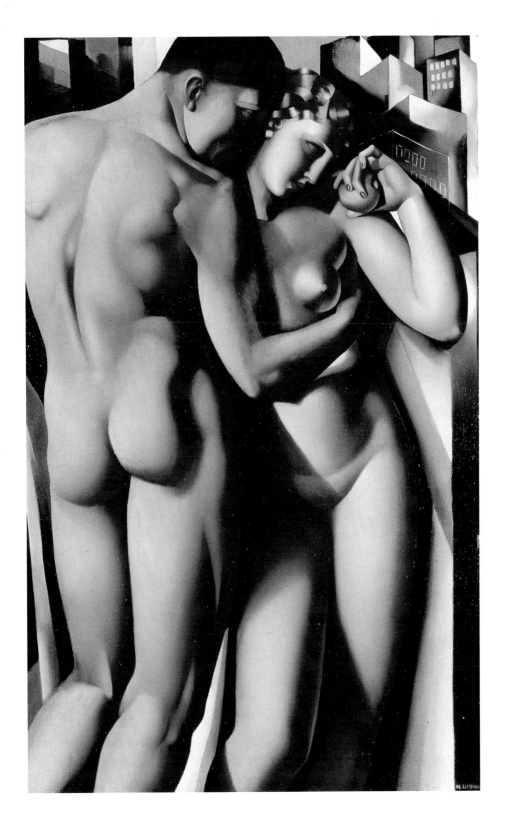

Adam and Eve, 1932
Oil on cardboard, 118 × 74 cm
Geneva, Musée d'Art Moderne, Petit Palais

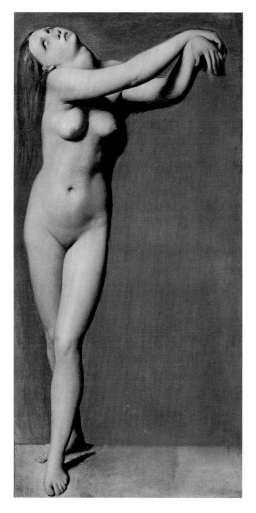

Jean Auguste Dominique Ingres
Study for *Roger and Angélique*, 1819
Oil on canvas, 84.5 × 42.5 cm
Paris, Musée du Louvre

Andromeda, 1927/28
Oil on canvas, 99 × 65 cm
Private collection

about their work!" As a form of polemic outburst, this was as old as the hills. The same arguments are dragged out every time the avant garde is to be put at a distance from the officially recognized aesthetic of the time.

However, this tirade was only a harmless beginning. Things were to get much worse. Was not Lhote, alongside Bissière, the author of that fearful expression "Rappel à l'ordre" – calling to order – which even today, at this distance in time, still sends a shiver down the spine? He would send everyone back to the "school of the museum", to the Louvre, where Courbet's *Atelier* had just made a triumphal entry. In his catalogue article for the "Les Réalismes" exhibition at the Centre Pompidou, Christian Derouet makes the following observation: "Realism, in itself, does not describe a particular kind of painting; rather, it characterizes a particular attitude on the part of the painter and in this sense often has a pejorative connotation, namely that one has set one's face against the current avant garde, that one is a reactionary."

In order, therefore, to understand the import of Tamara's contribution to her epoch, one must place her work back in the context of its time: namely, the nineteen-twenties, the period of the art deco compromise; the nineteen-thirties, the period of Lhote's infamous call to order. The whole era bears the stamp of the post-cubism of the Twenties and the neo-classicism of the Thirties. This is not to imply that Tamara did not transcend all this, nor that the eroticism or the distortions of her pictures did not have more to do with Ingres than with cubism; nor again that neo-classicism – by normal definition a virtuous phenomenon – did not, in her case, take in a pretty large measure of vice.

All the same, this does not alter the fact that Tamara's women fit perfectly into their epoch, an epoch of luxury and ease for the rich, and of extreme distress for the rest. The function of these women consists in their wearing of fashionable or childishly exotic clothes, or sometimes displaying of items of jewelry, against a background of affluent interiors. These long-legged creatures with their wasp-waists, looking as if they had just walked out of a fashion-plate, are reminiscent of those various "Eves" of the period: not very bright, staring emptily into space, of the type "be beautiful and shut up", such as were in great demand among bankers and politicians as willing luxury-mistresses. There are among Tamara's heroines some who one shudders to think might actually open their mouths and say something.

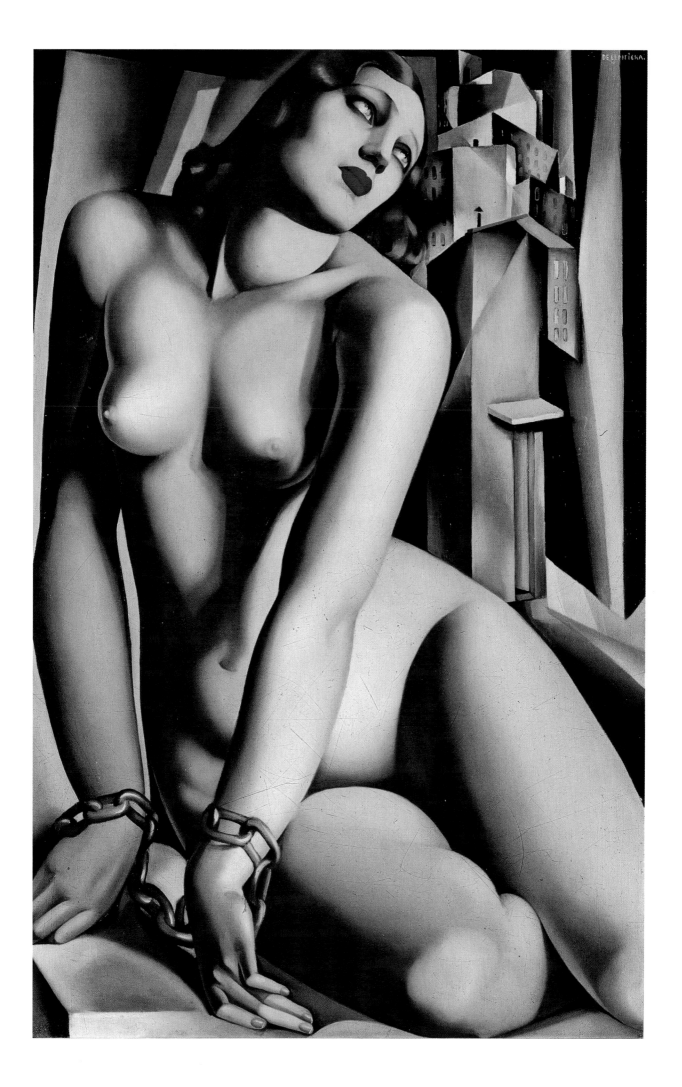

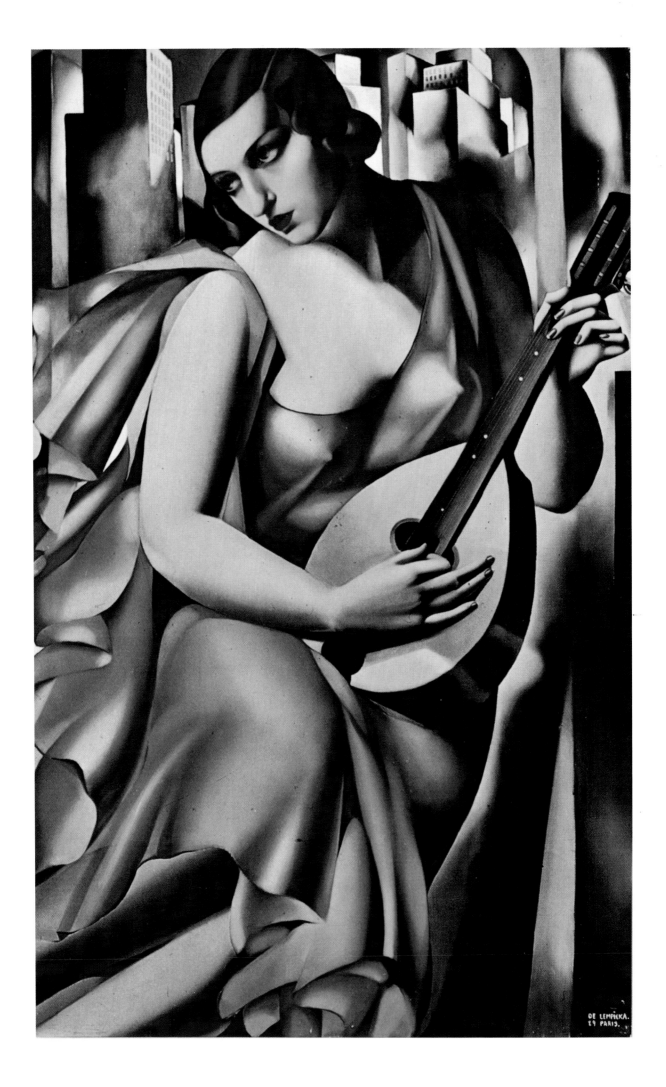

The art of the Caesars

There is a frequent tendency to remember nothing of the interwar period except for its avant-garde. All these isms, from expressionism and fauvism to dadaism, surrealism and abstract art. In so doing, one forgets that throughout the world this was a period of extreme nationalism, whose official face took the form of a monumental realism placed at the service of the respective government.

A short history lesson will suffice to explain this involuntary mechanism. The decade of the Roaring Twenties took to dancing in order to forget the horrors of the war. And Tamara danced along with the rest. The decade of the Hungry Thirties, by contrast, could no longer close its eyes to reality; its very beginnings were ominous, with the Wall Street crash of November 1929 ushering in the economic crisis, while its end was yet worse, with Hitler's invasion of Poland in September 1939. Between the two, the world was rocked by a succession of events, among them the Japanese adventure in China, the Italian invasion of Abyssinia, the promulgation of the racial laws in Germany and the Civil War in Spain.

What place does Tamara's work occupy in this context? Ricci explains it in a laconic sentence: "Her pictures, born of the cultural conglomerate of the moneyed classes during the Twenties and Thirties ..." had allowed "the notables and patricians of her time, even in the very early days of fascism, most of them resident in the Po valley, to surround themselves with the ultimate in neo-classicism, which was at the same time a post-cubism à la André Lhote."[8]

The period between the wars did indeed mark the end of the happy days of the fantasists, dreamers, utopians, creatives and the avant garde, who had had, during the Twenties, total freedom to exercise their inventiveness and to communicate with one another from Berlin to Moscow via Paris. Now, though, they were coming to be regarded as people lacking the proper civic attitudes, egoists indulging in their private games, considering it beneath their dignity to make themselves intelligible to the public. Art had to place itself at the disposal of all, and was no longer permitted to direct itself towards a narrow elite. After all, who was interested in the private problems of an artist or the personal gratification of a connoisseur?

Leaf from Tamara's sketchbook in the 1920s
Pencil on paper, 23.6 × 15.6 cm
Private collection

Lady in Blue with Guitar, 1929
Oil on canvas, 116 × 75 cm
Private collection

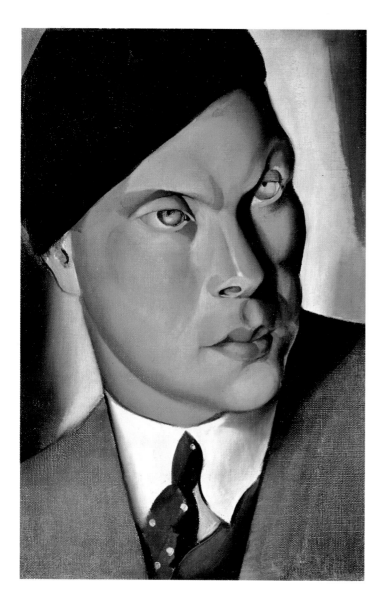

Portrait of Count Fürstenberg Herdringen, ca. 1925
Oil on canvas, 41 × 27 cm
Private collection

Portrait of Pierre de Montaut, 1933
Oil on wood, 43 × 30 cm
Private collection

Surrealism and abstract art were henceforth little games played by degenerate intellectuals, traitors. It was stupid, scandalous, or, at best, elitist. The surrealists were questioning the whole basis of art, of politics, of science, of society, and of money – in short, of everything that the totalitarian ideologies had raised to the status of dogma. As for abstract painting, well, it regarded the external world – as it is, or as others would have us see it – with a suspicion that was almost unclean. So, away with all these "wogs and dagos", away with these "degenerates" – it was for Big Brother to say what was good and what was not. To paraphrase Lhote, what was needed was a "return to order". After the *mélange des genres* which had characterized the nineteen-twenties, it was now necessary to re-establish a "hierarchy of values". Hierarchy, a word beloved of the fascists. Long live order, tradition, classical antiquity, historical values, meta-historical concepts, neo-anything.

Portrait of Pierre de Montaut, 1928/29
Charcoal on paper, 80 × 59.6 cm
Private collection

Irrespective of the country, no matter whether its regime was of the left or the right, the enemy was everywhere the same: the individualist, the utopian – the deviationist, as it soon became. In spite of their implacable mutual opposition, the children of the Second International and their antagonists, the fascists, made common cause against creative artists. Power had to be demonstrated, either by an abundance of academic references or by the use of costly materials. The Moscow underground, with its decor of marble and gilt, as though dating from the time of the Tsars, forms the companion piece to the Palais du Trocadéro in Paris, with its colonnades and sculptured nudes, so proudly inaugurated by the Popular Front.

Gigantism was the order of the day; and the socially inspired wall-paintings in Mexico with their cubo-syntheticist tendencies – in the manner of Diego Rivera – had much in common with the monuments erected by Hitler's architect Albert Speer, which Stalin greatly envied. Even the jewellery had the beauty of a heavy goods vehicle. Buildings and furniture were out, triumphal arches were in. The watchword was no longer "function", whether practical or economical, as in the days of the Bauhaus, of constructivism, of de Stijl or of "L'Esprit Nouveau" (the art journal founded by Le Corbusier and Ozenfant); what was demanded was symbolic evidence. Imposing monumentality was to be used to strike fear into the hearts of foreigners, while extravagance would reassure one's own subjects of prosperity at home.

The realism of the period, of whatever colour, was directed against all the other isms, and was itself the style which corresponded to the use of force, the style of the victor and conqueror. Examples of the same sort abound from Rome to Tenochtitlán. It was what Franco Borsi called the "monumental order", appropriate to this era of the Caesars in which Tamara's giants were celebrating their triumph. For Tamara herself saw herself as the herald of the strong, and the great triumph of her art was to reassure.

These days one might say that the representative art of the Twen-

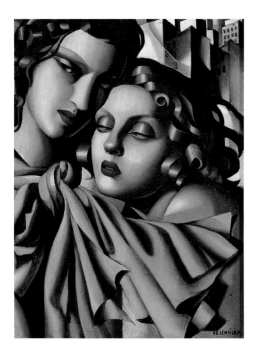

The Girls, 1928
Oil on canvas, 126 × 82 cm
Private collection

ties and Thirties, as the period itself experienced it, has in general become a form of social consciousness, a means of education, a culture "proletarian in content, national in form" (Stalin). Or as the Führer menacingly put it: "There are some painters who see things differently from what they are."

Tamara was at home in a world which accorded a place of honour and eminence to the nude, always providing it was athletic and muscular, whenever it was required to impose a type of recognized beauty allied to a certain sense of success, just as Hollywood, "Vogue", Elizabeth Arden or Helena Rubinstein imposed their own model of the star or the pin-up for obligatory imitation. The relationship between politics and art has always been very close. It was precisely to this that the philosopher Alain was alluding – not without a certain humour as involuntary as it was apocryphal, when he wrote in his "Système des Beaux-Arts": "Society must be supported by its furniture, just as a woman is supported by her corset."

But there too, the boundaries are fluid. Arno Breker's naked, sword-flourishing warrior, who dominated the Court of Honour at the new Reich Chancellery in Berlin, designed by Albert Speer and destroyed in the war, is not so far removed as one might think from the bathing-beauty brandishing a bottle of Coca Cola, nor from these grand-dukes, marquesses and other booted duchesses whose ravishing silhouettes Tamara thrust upon us, almost threatening and always perfectly turned out. The warrior is the colossal symbol of the Nazi regime triumphant, of the invincible Wehrmacht, while the celebrated Coca Cola lady, for her part, the typical American female, heralds the onset of the leisured civilization. Tamara's heroes seem to be the last representatives of a decadent world which is falling apart, in which they no longer appear as anything but shadows, parading their boredom and their conceit. The first is preparing for war, the second is creating a demand and fighting depression, while these last are closing the door on a world which will soon cease to exist. And it was here that the drama of Tamara de Lempicka would be played out, she too condemned like the others to disappear along with her creatures.

Tamara's paintings would have fitted perfectly with the interior decor of the liner "Normandie", the largest ocean steamer in the world at the time, a latter-day floating Versailles and, like Versailles, a psychological weapon wherewith to demonstrate the grandeur of France to the rest of the world and to the Americans in particular. Likewise they show a certain affinity with the Palais du Trocadéro – its stucco, its statues, its pillars. Nevertheless there is a certain nuance – and not a negligible one – which raises Tamara above all this and allows us to view her works with a fresh eye today. Giancarlo Marmori rightly notes that one can't just lump everything together: "It would be too restrictive just to include Tamara de Lempicka in a catalogue of post-cubist and classico-deco art. The psychological and physical intensity of her subjects, their meta-anat-

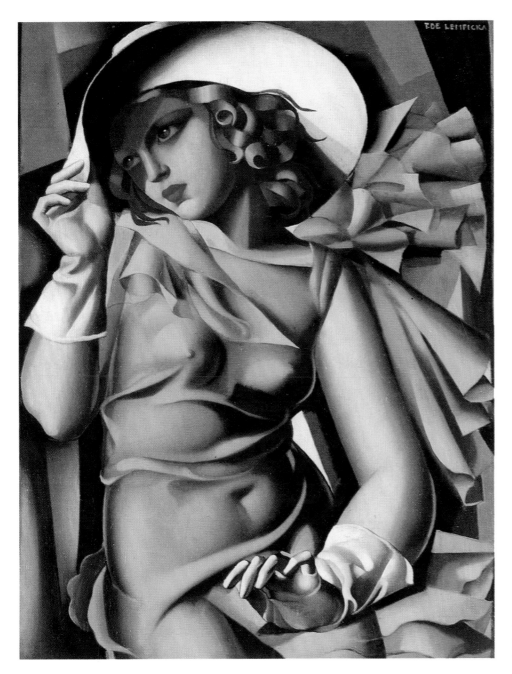

Girl with Gloves, 1929
Oil on canvas, 53 × 39 cm
Paris, Musée National d'Art Moderne

omies and tics, not to say their grimaces, are her way of introducing the very specific exaggeration of the 'Neue Sachlichkeit'. The exaggeration, and also the hypocrisy. We find ourselves face to face not with an elegant anthropomorphic decoration or with fresco silhouettes for the Normandie or the Palais de Chaillot (alias the Palais du Trocadéro), but with extremely lively creatures whose innermost emotional life is sometimes brutally laid bare."[9]

Quite obviously, Tamara's figures are not stereotypes in the manner, for example, of the beautiful *kolkhoz* peasant girls of the Stalin era, nor do they have the doe-eyed vacuity of the goddesses which keep cropping up in the various renditions of the *Judgement of Paris,* a subject which, under the brush of Hitler's favourite painters Saliger, Ziegler or Friedrich, enjoyed a veritable heyday.

Everything, indeed, is relative, and compared with these goddesses with the vacuous stares, trampling along like a flock of

"My aim is: *never to copy.* Create a new style, bright, luminous colours, and scent out the elegance in your models."

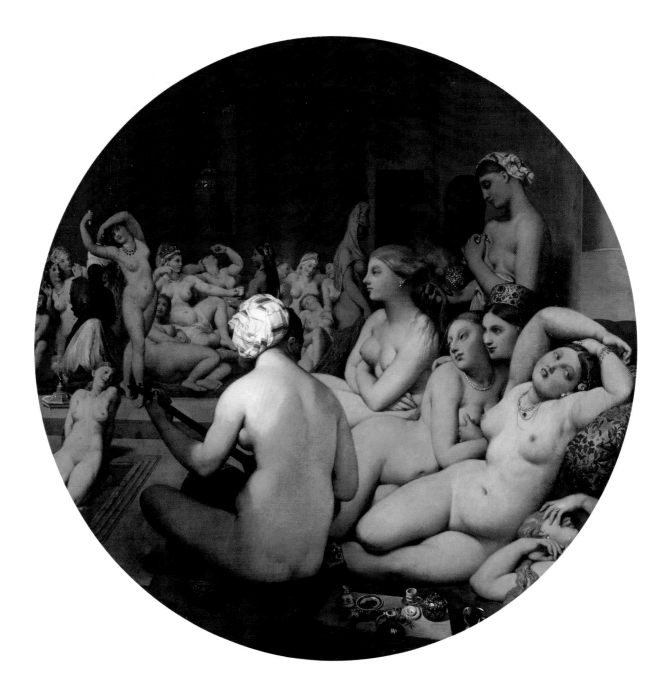

Jean Auguste Dominique Ingres
The Turkish Bath, 1862
Oil on canvas, stretched on wood, Ø 108 cm
Paris, Musée du Louvre

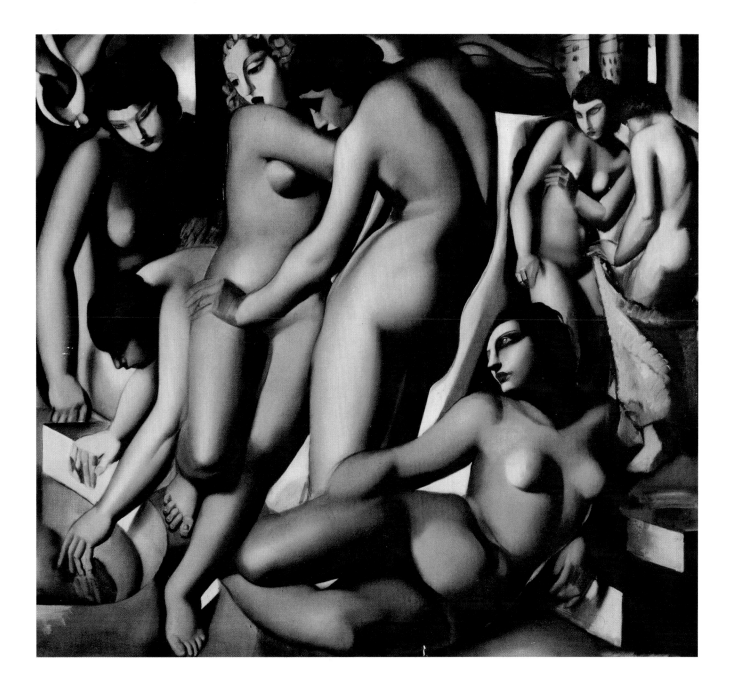

Women Bathing, ca. 1929
Oil on canvas, dimensions unknown
Private collection

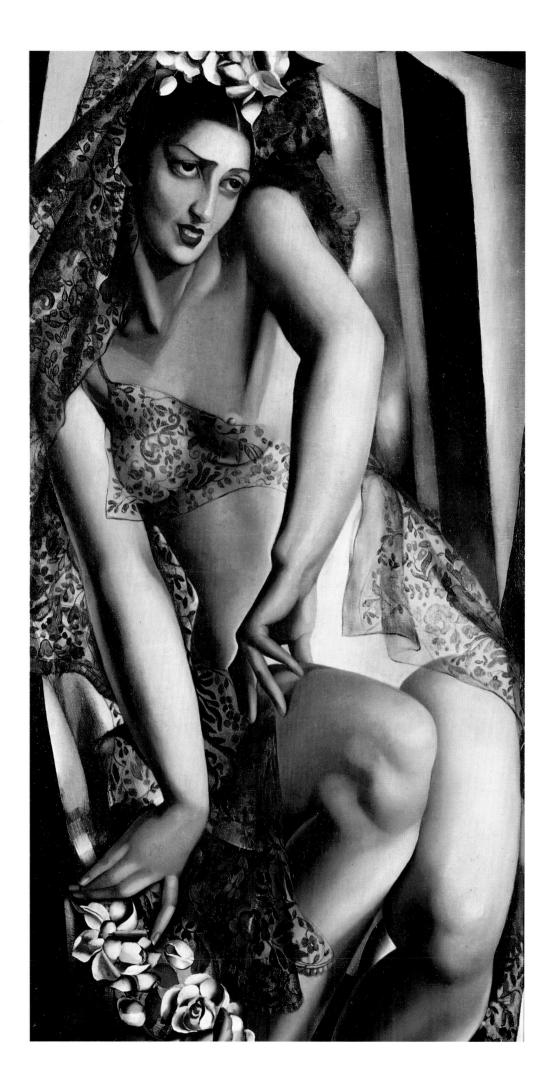

sheep, obviously intended only for the recreation of the warrior and for reproduction, and thus the future and the grandeur of the nation, Tamara's heroes and heroines all have some individual feature which distinguishes them from the common run of mankind. Thus Marmori lists what he calls "a quite hair-raising arrogance" evident in the gaze of "H.I.H. the Grand Duke Gabriel Constantinovich" (illus. p. 19), "the like of which one would not expect to find in the gallery of society portraits being turned out by French painters of the time." He considers that the "perpetually hypochondriac" Marquis d'Afflitto (illus. p. 9) "bears an uncanny resemblance to Peter Lorre", while Count Fürstenberg-Herdringen (illus. p. 30 left) comes across to him as "a Mephistopheles in the Berlin of Klaus Mann."

Yes, there is something disconcerting, even frightening, about these figures; they would not be out of place in a Hitchcock horror movie. These angular dinner-jackets, as worn by the Marquis d' Afflitto or the Marquis Sommi (illus. p. 8), these shimmering russet uniforms like that of Grand Duke Gabriel, are positively radiant with menace.

As for the nudes, in general they are, in Marmori's view, "dripping with some carnal presence, verging on kitsch, or at the very least, transgression ..." The arrogance evinced by Tamara's women hits one like a slap across the face. Of course they are interested in love, or rather, sex; but woe betide the partner who shows the slightest sign of weakness. They have almost nothing in common with those Venuses or Ninis who have shared the honours of the canvas throughout the history of art.

It was Plato who, in the "Symposium", first expounded the theory of two kinds of erotic love – the heavenly and the mundane. Renoir said the same thing less obliquely: "The naked woman rises either from the sea or from her bed; she is called Venus or Nini – there is no better way of portraying it." An unashamedly erotic nude, if entitled *The Birth of Venus* or *Susannah at the Bath*, was considered respectable, ennobled as it was by the mythological or scriptural reference. Thus all the dryads, nymphs and odalisques created by the brushes of the academicians could be exhilarating, suggestive or frankly libidinous – indeed, they were expected to be – and yet add glory to the salons, besides making a fortune for their creators.

The Nini category, by contrast, included the works of that uncouth band, the impressionists, along with Courbet their forerunner – that "flesh producer" – and their ringleader Manet. They preferred to paint courtesans, working-class girls surprised in an intimate moment and giving the impression that they had only just got undressed, having laid aside a frayed shawl, taken off a disreputable skirt, thrown off their dirty boots, and looking as if they were now, like Manet's *Olympia*, waiting for a lover or a client, who could not, it seems, be far away.

Paris, Studio in the rue Méchain, dressing-table in the bedroom, ca. 1929

Portrait of Nana de Herrera, 1929
Oil on canvas, 121 × 64 cm
Private collection

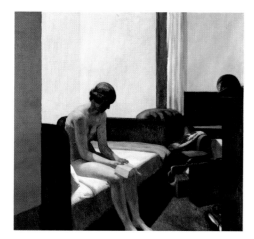

Edward Hopper
Hotel Room, 1931
Oil on canvas, 152.5 × 165.7 cm
Lugano, Switzerland, Thyssen-Bornemisza
collection

Alongside these mythological Venuses and pavement Ninis, Tamara, with her feminine figures drawn from the elite, would appear to have opened up a third path, invented a third sex à la Simone de Beauvoir. This third way, unique to Tamara de Lempicka, fits very comfortably, it is true, into the "realist" and "monumental" pattern which had seized the whole world at this time; but it also fitted very well into the decadent milieu peopled by homosexuals of both genders, which she herself frequented.

The photographic realism of the Soviet painter Isaac Brodsky, as evinced in his *Lenin at the Institution for Girls in Smolny*, dating from 1930 – reminiscent in its way of David's *Napoleon at Work* (1812) –: does it not sound an echo of *The Hotel Room* (1931) by the American painter Edward Hopper (illus. p. 38)? Within an equally banal setting, both artists depict fragility – the one of a venerated leader, the other of a simple woman, loved, reading, naked and defenceless. In the two works we find the same realism, the same loneliness, the same pathos, the same decor, almost impersonal in its banality. Is it not a comparable Nietzschean "will to power" which provides the unifying thread running through the pictures of Tamara de Lempicka?

In order to achieve success in life, it is necessary above all to think of that and nothing else. And Tamara thought of that and nothing else: succeed! Tamara, a refugee with nothing but a few jewels to sell, wanted to succeed. At the same time she wanted to make a fortune and live in the grand style. But how? She could not count on her husband: Tadeusz Lempicki was a Don Juan and fast liver whom she had won for herself in Russia in the face of fierce competition from a host of admirers, and whom she had married with great pomp in the Chapel of the Knights of Malta in Petrograd in 1916, the very year in which the great Russian Empire had heaved its last sigh.

As a refugee, Tadeusz was a changed man. He had lost all his charm, while Tamara his wife remained, as they say in Russia, "a little hot potato." Lempicki was bored stiff in their dirty little room in a cheap hotel, reading detective stories, and, for want of anything better to do, fathering on his wife a child: Kizette. Tamara, for her part, on the advice of her younger sister Adrienne, who was studying architecture in Paris in order to earn her living, took up painting, the only talent she possessed, having, in her youth, scribbled around, drawn and painted water-colours. A palette, a sable-hair brush, paints, an enrollment at the Académie de la Grande Chaumière – which offered free instruction and provided models – and the props for the performance were assembled. All that was needed now was the lead player, the star. Someone to make the public catch their breath and to receive the ovation of the audience.

Kizette, her daughter, reports in a book of memoirs of her mother that Tamara had, from that moment on, a goal, a plan: "after every two paintings sold, she would buy a bracelet, until one day she

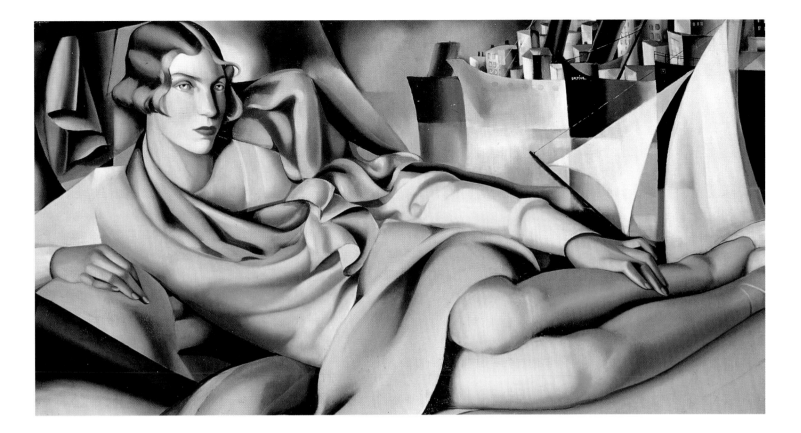

Portrait of Arlette Boucard, 1928
Oil on canvas, 70 × 130 cm
Private collection

would have covered herself in diamonds and jewels from her wrists to her shoulders."

From then on, Tamara was to seize every opportunity for success, leave no possibility unexploited of making a name for herself. She herself laid down the ingredients for the sauce of this success. And first of all she chose sides and selected her style: not the avant-garde, with its uncertainties and fluctuations, synonymous with the haggard artist in his garret, but a subtle compound of post-cubism and fashionable neo-classicism, with a touch of Ingres to satisfy not only her own erotic urges, but also the libidinous dreams of the bourgeoisie, her future customers, those with the money to buy.

A further important point concerns the models: only the elite were to be worthy of a place on her canvas. Her name Tamara de Lempicka, which she used to sign her pictures, would be her pass-port. When she appeared at a party given by Paul Poiret, or visited the louche but chic night-club run by the celebrated lesbian Suzy Solidor (illus. p. 58) in Montmartre, or met Braque or Gide (whom she amused, and whose portrait she painted) in the "Dôme" or the "Rotonde", then it was for her as much work as it was pleasure.

Her daughter reports that "when she came home late from a party, still excited and brimming over with energy, she would wake Ki-zette to tell her of the famous artists and writers whom she had met, of the counts and dukes with whom she had danced, of the coun-tesses and duchesses who had invited her to luncheon, to dinner, to the opera or to another party."[10] She always gave the impression of being just about to go out to meet some customer, model or friend.

"There are no miracles. There is only what one does oneself."

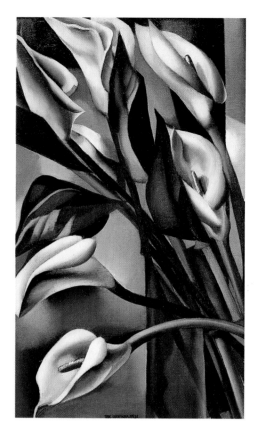

Calla Lily, 1931
Oil on wood, 55.3 × 35.5 cm
Santa Fe, New Mexico, Laura L. Carpenter

St. Moritz, 1929
Oil on wood, 35 × 26 cm
Orléans, Musée d'Orléans

"Loving art and high society in equal measure," as Jean Cocteau said of her, is an inadequate description. In spite of a leading a life of exhausting worldliness, there was still back-breaking work to be done. "The days were simply too short," she remarked later to Kizette à propos of this period of her life. "Sometimes I would go out in the evening, not come home until two, and then paint until six by the light of a blue lamp."[11]

As the magnificent wild beast on the loose in the capital, not only of France, but – for that brief period – of art as well, Tamara gradually developed what her daughter called "her killer instinct". In her book, Kizette describes it thus: "She had her own law, the law of the nineteen-twenties. She was only interested in those she considered the better class of people: the aristocracy, the wealthy, the intellectual elite. She had the feeling, typical of all talented people, that she deserved everything which came her way, and this gave her the freedom to mingle only with those who could help her or nourish her ego in some way or other. She lived on the Left Bank, as was proper for an artist, depising everything that was bourgeois, mediocre or 'pretty'. She dressed luxuriously so as to dazzle her fans, while shrouding her past in a veil of mystery. Quite deliberately, she cultivated uncertainty as to her age, her life in Poland and Russia, and even her family. The Polish girl of good family, the child bride, the émigrée, the young mother – all disappeared behind her canvases as a star disappears behind the screen of her dressing-room, to emerge once more as the modern, bewitching, sophisticated – not to say decadent – beauty of the celebrated *Autoportrait* which she painted a few years later for the cover of the magazine "Die Dame". 'I live on the fringe of society,' Tamara wrote, 'and the rules of normal society have no currency for those on the fringe.' From the very beginning, she had placed her stake on style."[12]

But by what style was she to set herself apart from other painters? There were various recipes, and one she described to her daughter thus: "I was the first woman to paint cleanly, and that was the basis of my success. From a hundred pictures, mine will always stand out. And so the galleries began to hang my work in their best rooms, always in the middle, because my painting was attractive. It was precise, it was 'finished'."[13] And indeed, when Colette Weil exhibited her work, it was not uncommon for clients who had come to buy a Matisse or a Marie Laurencin to leave with a few Lempickas under their arms.

"At the start of my career," in the words of Tamara to her daughter Kizette, "I looked around me to discover that painting was in a state of total ruin. I felt repelled by the banality into which art had descended. I was revolted. I was looking for a metier which no longer existed. I worked nimbly with a supple brush. I was interested in technique, in craftsmanship, in simplicity and in good taste. My goal was *never to copy*, to create a new style, bright, luminous colours and to scent out the elegance in my models."[14]

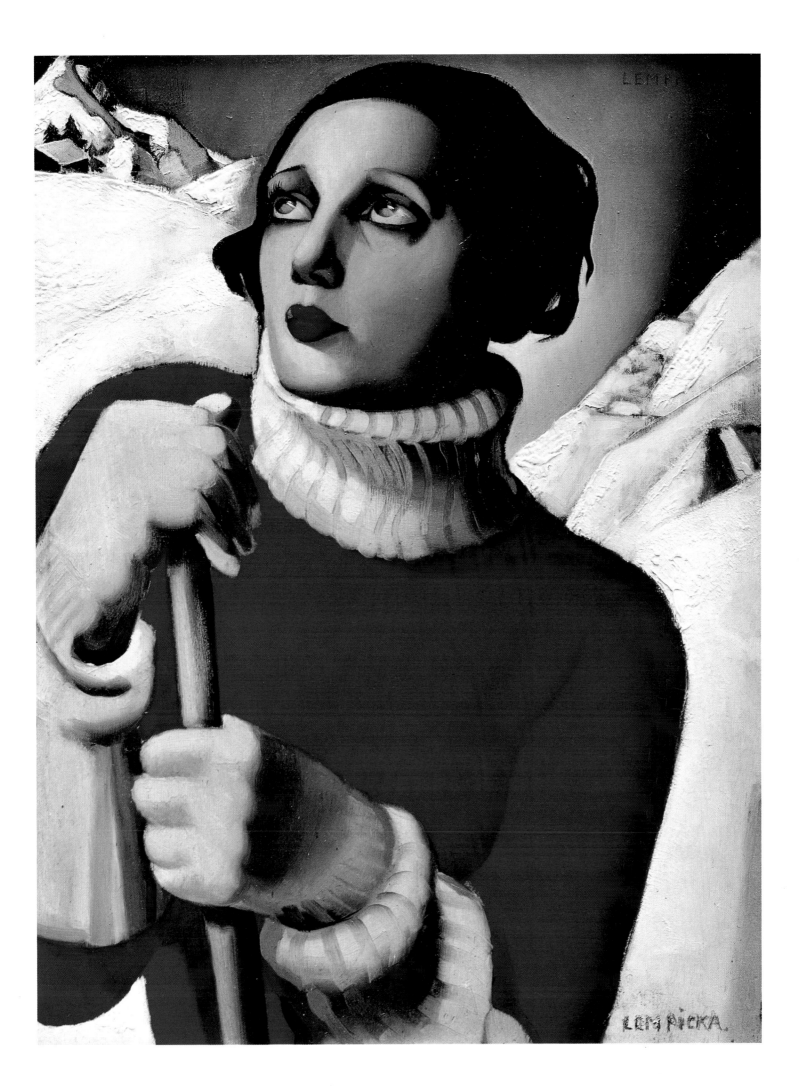

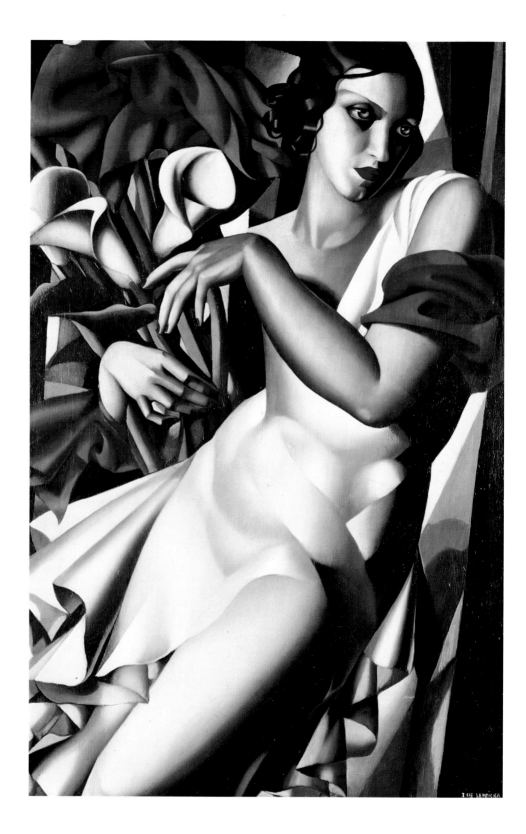

Portrait of Ira P., undated
Oil on wood, 99 × 65 cm
Private collection

And how was she to set herself apart from the other art deco painters currently in fashion? Here too Tamara put her trust in her temperament, while drawing on what she had been taught.

It was through André Lhote, to whom she owed so much, that she discovered and learned to love Ingres, that erotic artist *malgré lui* in the guise of the great classical painter, and incidentally no less ambiguous than she herself. Time and again his work serves as a reference point for her, whether in her groups of female nudes *(Group of Nudes, Women Bathing)* (illus. pp. 24, 35), both quite frankly in-

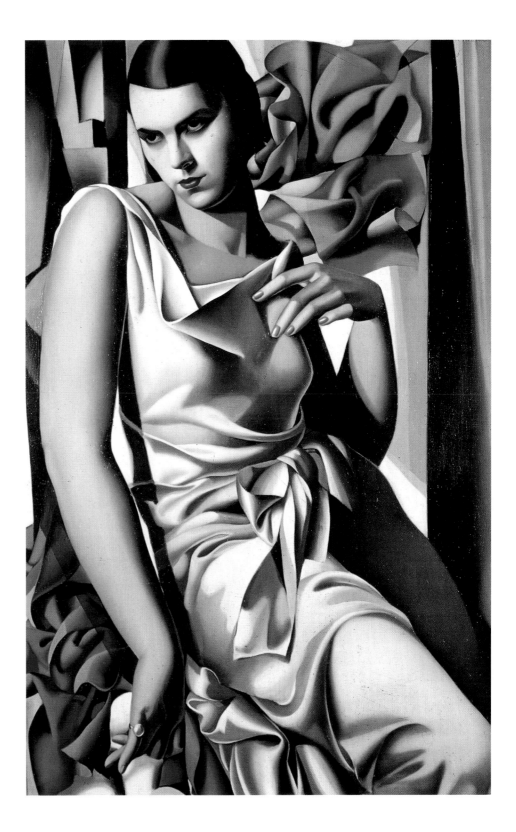

Portrait of Madame M., 1930
Oil on canvas, 99 × 65 cm
Private collection

spired by Ingres' famous *The Turkish Bath* (illus. p. 34), or in her nudes such as *Andromeda* (illus. p. 27) and *Nana de Herrera* (illus. p. 36), in which are rediscovered the same erotically charged distortions employed by the creator of *Angélique* (illus. p. 26).

Thus Tamara pulled off a double coup: on the one hand she hauled herself up towards Ingres, while on the other flattering herself with practising the same perversity. The result: rave reviews, as the critics heaped invaluable publicity upon her as the exponent of a "perverse Ingrism".

Paris, Studio in rue Méchain, Bedroom, ca. 1929

It is in fact impossible to talk of the works of Tamara de Lempicka without evoking the spirit of Ingres and his eroticism, which was all the more remarkable in that this patrician figure was sincerely attached to the concept of "virtuous art" (not something that could be said of Tamara), as well as to Raphaelesque purity, and had moreover a sense of sin, struggling to overcome the feelings of concupiscence which his paintings of ladies might provoke. It is of course plainly evident that Tamara was plagued by no such scruples, let alone a "sense of sin"; but for opposite reasons, the result is the same: a highly efficacious hypocrisy in both cases. These marvellous nude female bodies seem to be unaware of the lust which they excite in the beholder. Just as Tamara herself seemed to be unaware of the stare of the visiting Ricci when she crossed her legs. The looks, the exposed flesh, the skin-tight dresses: if they aroused desire, they did not know it. The sensuality and the eroticism with which Ingres, as though in spite of himself, has imbued the works which we so admire today, begin with his portraits of women, towards whom he, like Tamara, always maintained an attitude as ambiguous as towards his female nudes. He always seems to be denying his own sensuality, while Tamara positively projects hers: "There is nothing more suggestive," wrote Gaétan Picon in a passage which fits Tamara like a glove, "nothing more subtle, nothing more 'Ingresque', than this moment of harmony between a neck and a collar, a velvet fabric and a piece of naked flesh, a scarf and a lock of hair, nor than that line which marks the point of meeting and recognition between a breast and a bodice, an arm and a long glove. If the portraits of women have a radiance of their own, then it is because they – like the nudes, but with less frankness, naturally – arise from the glow of desire."

And indeed, in the works both of the master and of his disciple, there is this combination of fabric and bare flesh. Shoulders and arms are of the same material as the silks and the satins; the creases in the fabric of the dress are like the folds in the skin. "Let us not say," Gaétan Picon went on, "that the body wanted to burst forth, but rather that the dress was prepared to fall away, to humble itself in the face of such a triumphant apparition." In Tamara's work we find countless such correspondences with Ingresque perversity: in her portraits of women, where it is difficult to tell – for example in the *Portrait of Ira P.* (illus. p. 42) – where the dress ends and the flesh begins; or in the various portraits of Kizette as a child, in which – à la Balthus – one almost expects to catch a glimpse of the knickers; or in the *Portrait of Nana de Herrera* (illus. p. 36), whose body seems more tattooed than clothed by the diaphanous laces in which she has draped herself in order to emphasize her nudity all the more, somewhat in the manner of Botticelli's creatures; or in the *Portrait of Arlette Boucard* (illus. p. 39), dating from 1928, in which both blouse and skirt are open to the four winds, or in her other portrait painted in 1931, with its deliciously crumpled look re-

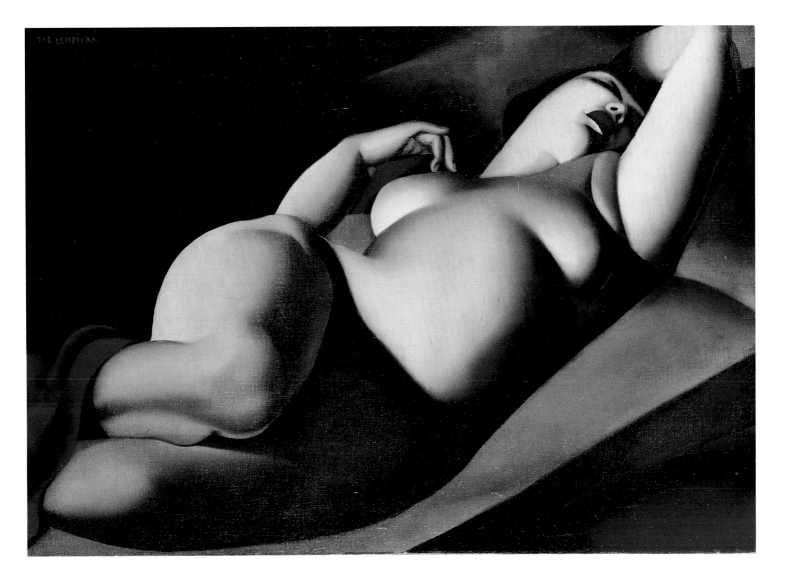

vealing in intimate fashion the curves of the thighs and the geometric globes of the breasts, underlined by the suggestive hairs of her fur wrap. The pinafore dress in the *Portrait of Mrs. Alan Bott* reveals in reality more than it conceals, which in like measure also applies to the pink blouse in the picture of that name.

Tamara experimented extensively with so-called "plastic rhyme", above all in the painting entitled *Women in Fur Collar*, where the shoulders of the sitter, Baroness Trévès, "rhyme" or harmonize with the back of the armchair and the fur collar in a purely plastic analogy. It would no doubt have been a source of some irritation to Monsieur Ingres, a man of orderly habits, a bourgeois through and through, respectful of propriety and a defender of tradition and established order, if he had been told that at the age of eighty-two he had, in his *The Turkish Bath* (illus. p. 34), just painted an erotic masterpiece as well as one of the greatest influences on the modern painting of the future. A compact, circular mass of naked bodies, female without exception, arranged in a geometric composition emphasized by the choice of a tondo shape for the canvas. Curves which were later to serve as a point of reference for the cubists, and in yet greater measure for the post-cubists like Tamara.

Beautiful Rafaela, 1927
Oil on canvas, 64 × 91 cm
Paris, private collection

ILLUSTRATION PAGE 46:
Portrait of Madame Boucard, 1931
Oil on wood, 135 × 75 cm
Private collection

ILLUSTRATION PAGE 47:
Portrait of Dr Boucard, 1929
Oil on canvas, 135 × 75 cm
Private collection

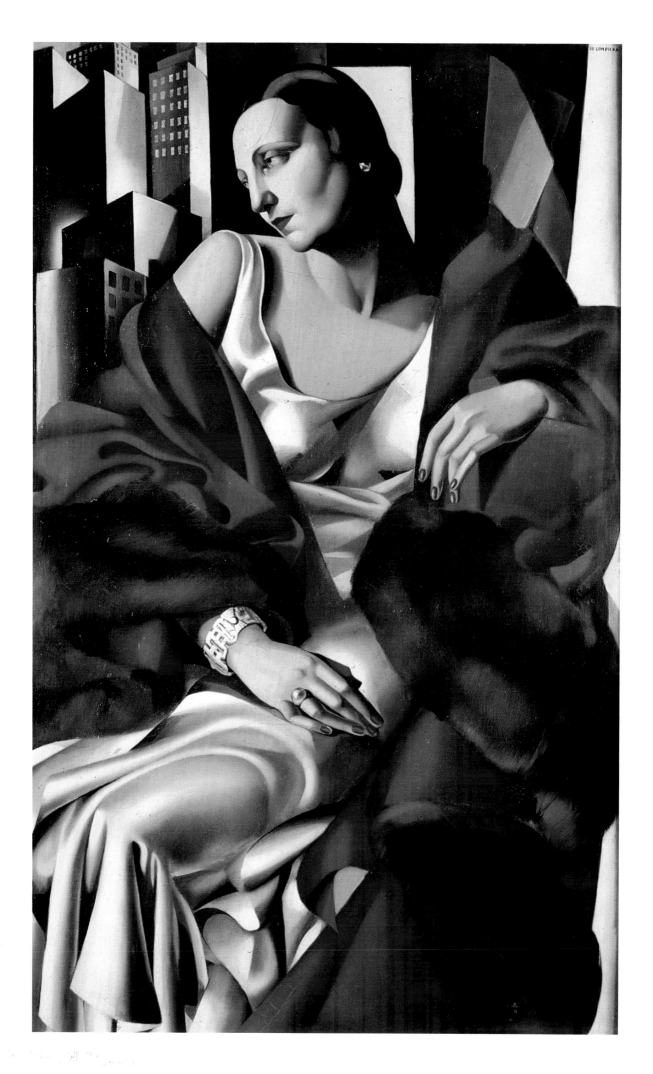

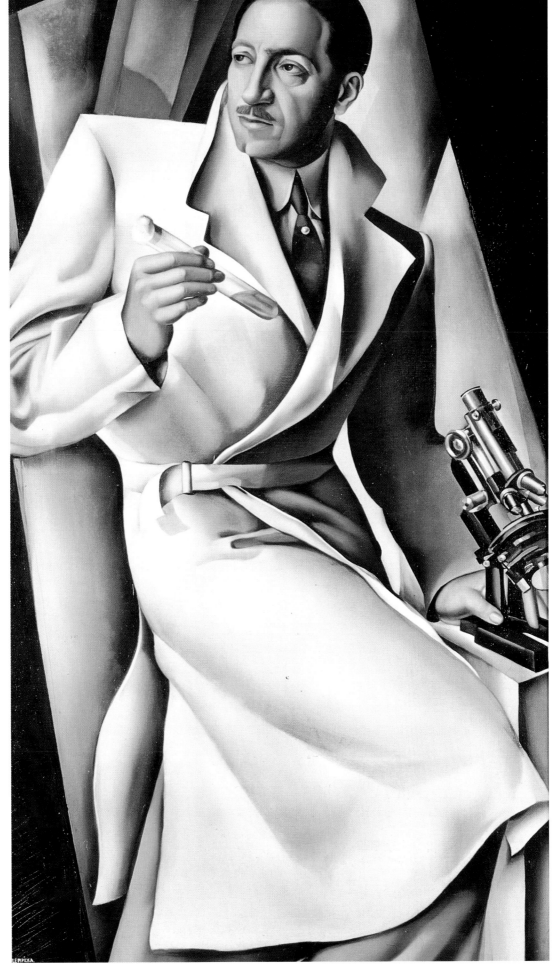

André Lhote
Reclining Nude, undated
Oil on canvas, 81 × 105 cm
Private collection

Nude, 1924
Oil on canvas, 70 × 58.4 cm
Luis Eulalio de Bueno Vidigal Neto

There can be no doubt that Tamara de Lempicka must have spent some time studying *The Turkish Bath* before painting her own groups of nudes. This picture is indeed a veritable firework, an orgy of rarely equalled audacity, a pretty well exhaustive anthology of the nude: women submitting, women perfuming themselves, women showing their breasts, women engaged in positively extravagant caresses, women intertwining. It is not just Tamara's heroines, but those of Ingres too, who sit in expectation of pleasure, or else luxuriate in the memory of lust enjoyed ...

Ingres' contemporaries could not resist the temptation to count the vertebrae of his *Grand Odalisque;* it seems she had three too many. Likewise the sinuous arm of Thetis in his "Apotheosis of Homer" is of exaggerated length. "A woman's neck can never be too long," preached the master, who invoked the exaggeration of the line "to correct Nature by means of herself". Baudelaire criticized these distortions, these corrections, but they were retained by the moderns from Cézanne to Matisse and Picasso. "Here," wrote the poet of the "Fleurs du mal", "we have a navel which has wandered up to the rib-cage, and there a breast pointing towards the armpit."

During the art classes he gave to Tamara, André Lhote time and again spoke with enthusiasm of the overlong backs and arms in Ingres' work, and dutiful pupil as she was, she did not forget the lessons her dear teacher had imparted. Identification with Ingres goes so far in her case that on occasion she even reproduces one of the distortions typical of this defender of tradition and established order. Thus his heroines, from Thetis to Angélique, have been described as "goitrous". Now by comparing Tamara's *Andromeda* (illus. p. 27) with Ingres' *Angélique* (illus. p. 26), one cannot help noticing the same flesh, the same distortion of the arms and body, and even this goitre, which, as everyone knows, is the attribute of those women whose hypertrophic thyroid gland predisposes them to a hyperactive sex life.

It must be said that Tamara was not the only post-cubist artist of the period to have been inspired by *The Turkish Bath* (illus. p. 34). The art deco painters discovered in this work "cone and cylinder" domesticated for bourgeois use, and appropriated to themselves the following aphorism of the chief representative of academic painting: "Beautiful forms: flat surfaces with curves." A phrase which sums up one of Tamara's most beautiful paintings, *Andromeda,* in which she sets off the sensuous curves of the virginal heroine against the angular constructions of the modern city which forms the background to the work. It is a contrast found in other portraits too: the 1931 version of *Portrait of Madame Boucard* (illus. p. 46), in which the rumpled curves are set against a background of geometric skyscrapers.

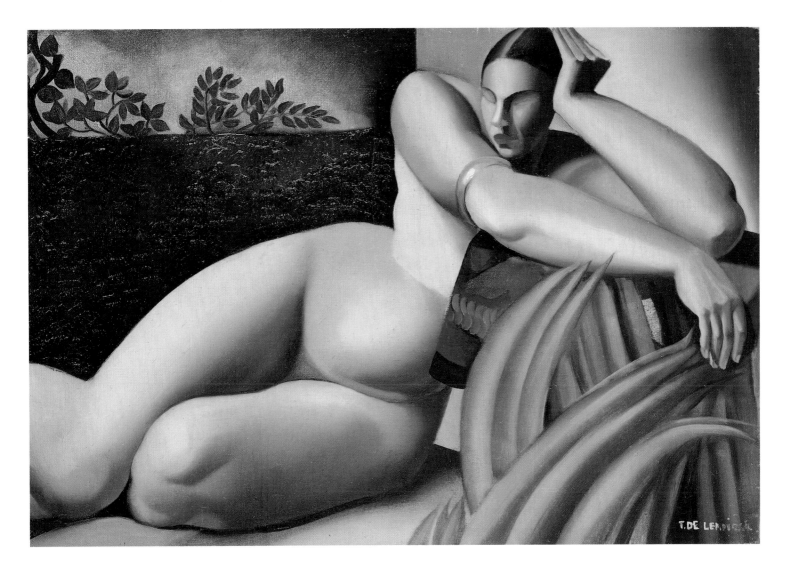

Reclining Nude, ca. 1925
Oil on canvas, 37.8 × 54.5 cm
Private collection

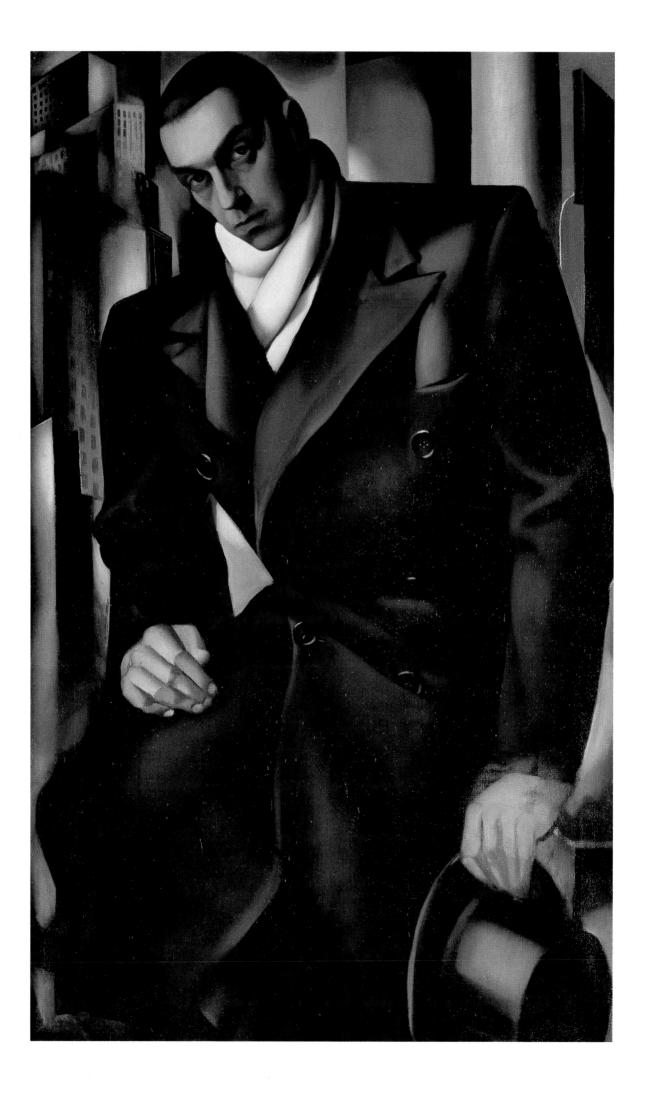

Bedtime stories:
the beautiful young woman and the ugly old dwarf

The adventure with Gabriele d'Annunzio, at that time known throughout Europe as a poet, novelist, dramatist and lover, marked Tamara's début in terms of success, her rite of passage from Bohemia to the Dolce Vita. While d'Annunzio had but one goal, namely to add this splendid creature, "smart" and *en vogue* as she was, to his collection of mistresses, Tamara for her part could already glimpse the possibility of a superb media coup. Kizette calls a spade a spade when she describes the cynicism with which the whole operation was conducted: "Driven by her hunger for a success hitherto withheld from her, and dying with desire to become a famous artist, she could hardly wish for anything more opportune than to paint the man whose eccentric personality had left its mark on a whole epoch and who was admired and venerated by all who knew him. A Lempicka portrait of d'Annunzio would be a sensation, a masterpiece which would put everything done hitherto in the shade, even the poet's scandal-ridden affair with Romaine Brooks, who had by then become a lesbian of some notoriety, following her ambiguous liaison with d'Annunzio. She was in no doubt whatever about his intentions, but then were not all real men like that? It was something to which she had long since grown accustomed. She had also learnt to combine art and sensuality in her life. D'Annunzio was by then an old man, of no physical attraction whatever, but he had a wit and strength of character which she wanted to capture on canvas ... At this time, her success was more social than artistic, and she knew it. But if others did not take her painting as seriously as she did herself, that was their problem, not hers. D'Annunzio seemed to be infatuated with her, and that flattered her. With her 'killer instinct', she thought that she could at one and the same time profit from his attentions and place them at the service of her art."[15]

Details of this affair, which partook somewhat of the nature of a vaudeville farce, can be found in the diary kept by d'Annunzio's housekeeper – and mistress – Aelis Mazoyer. Rediscovered, these observations were published by Ricci in 1977, to Tamara's evident displeasure. Kizette reported her mother's outraged reaction thus: "She protested at having her name mentioned in the same breath as

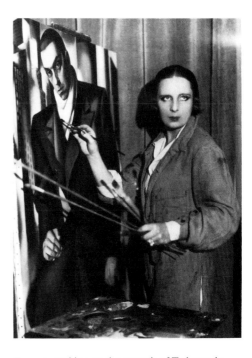

Tamara working on the portrait of Tadeusz de Lempicki, 1928

Portrait of a Man (Incomplete) (Portrait of Tadeusz de Lempicki), 1928
Oil on canvas, 126 × 82 cm
Paris, Musée National d'Art Moderne

Facsimile of letter from Tamara to Gabriele
d'Annunzio, Florence, 1926

the 'dirty washing' of some 'chambermaid'. She also protested against this insult to the memory of a great Italin poet (although she herself had called him an old dwarf in uniform). She protested at a book which while purporting to be dedicated to her art, was in fact full of bedroom tittle-tattle of the worst kind ... 'That's neither my work nor my art,' she would fulminate whenever Ricci's book was mentioned. 'People will know or remember nothing of me except the lies of this chambermaid.' In spite of her criticism, the work was a great hit with the European public, and re-awakened an interest in her pictures, prices for which shot up in the late seventies ...'[16]

For all that, the section in Aelis Mazoyer's diary with the title "Tamara at the Vittoriale" is in fact pretty harmless. "Il Vittoriale" was a country house on the banks of Lake Garda, which d'Annunzio had transformed into a fairytale castle in the manner of Ludwig II, the mad king of Bavaria, a dream palace reflecting his private fantasies, but resembling a prop for some Hollywood epic. To judge by the correspondence between these two exceptional personalities, the initiative for a meeting came originally from Tamara. This at any rate is the evidence of the wording of her first letter, couched in less than perfect French (facsimile left). In translation, it reads as follows: "Friday. Dear Maestro and Friend (as I hope and most heartily wish), Here I am in Florence! Why Florence? To work, to study Pontormo's sketches, to purify myself through contact with your great Art ... How I regret not being able to express my ideas. I would so much like to have spoken with you, shared my thoughts with you, for I believe you are the only one who understands everything and yet does not judge me to be mad, you who have seen everything, felt everything, tried everything ... For the Christmas holiday I shall be returning to Paris. I shall be passing through Milan, where I shall probably be stopping over for two days. Would you like it if I were to call on you? It would be a great pleasure for me ... I send you, my brother, all my thoughts, good as well as bad, the naughty, and those that make me suffer. Tamara de Lempicka."[17]

The correspondence continues in this gallant, if somewhat affected style. "Sunday. Thank you, I'm coming! I am so glad and so afraid. How are you? Who are you? And I, shall I please you at all, coming along like a little student, without my Parisian wardrobe, my cosmetics etc., etc. ..."[18]

The "brother" meanwhile was preparing his nets, and remembered only the "naughty" side of the missives. Cynic that he was, he was not taken in. "Come to the Vittoriale", he wrote, "the muses of art, music and literature will be assembled." The Princess of Piedmont, one of his numerous mistresses, had just departed. The "housekeeper" noted in her memoires: "I shall draw his attention to how amusing it will be if the Polonaise arrives within an hour of the princess's departure. The bed will still be warm, I guess. When I enquire after his intentions, he says he plans to proceed with caution, to do nothing in haste, to treat her like a proper lady, and adds: 'Per-

haps it will be a disappointment like so many others, but even if it doesn't work out, she could still paint my portrait – that would be good publicity for her ...' "[19]

So there were two "killers" on the loose in the jungle. May the fittest survive! There was, however, one man who had no illusions, namely Tamara's husband Tadeusz. He knew quite well that she only painted portraits of her lovers, such as for example the Marquis Sommi Picenardi, with whom she went to Turin. "The first day, we went to the opera. The second day we went to bed. We stayed in bed for three days on this first occasion." As Kizette notes in respect of her father: "Lempicki now referred to her sardonically as the woman 'with golden hands', accusing her of humiliating him in the eyes of the world with these portraits of her lovers ..."[20] There followed the affair with d'Annunzio, and every two days he sent a letter to his wife demanding her return "or at least to write back."

Let one hand wash the other: this was the principle which had always been employed by d'Annunzio, whom Lenin had called the "only genuine Italian revolutionary" and whom Mussolini was now protecting. He had a long arm, and not much shorter was the queue of women presenting themselves at the Vittoriale to solicit an intervention on his part in return for favours on theirs. Thus Carlotta Barra, a ballerina no more than seventeen years old, was staying in the house when Tamara arrived. She was hoping that d'Annunzio would introduce her to Diaghilev, and that she would thus be engaged with the Ballets Russes. While the housekeeper, burning with curiosity to see her naked, was helping her to dress, enthusing all the while about her muscular thighs, the result of constant exercise, Carlotta could only manage the anxious question: "Do you think the Comandante will recommend me for Paris?" Whereupon Aelis replied brusquely: "See that you please him naked. He's dying to view your quaintness."

The whole household was looking forward to the arrival of the "Belle Polonaise" with anxiety. The aging Comandante was surrounded namely by a regular harem. At its head, as *châtelaine*, stood Luisa Baccara, a former pianist who now performed for him the function of mistress of the revels. Each of his houris was required to pleasure him in turn, a task which included bringing his daily dose of cocaine. Then there was Emilia the maid, Luisa's younger sister; and the faithful housekeeper Aelis, and the prostitutes procured for him, and the numerous female visitors to the Vittoriale – a brothel with the motto "We never close".

The Comandante was determined to spare no pains, and had a salute fired in Tamara's honour from the cruiser "Publia" which was moored in his garden. He punctuated each shot in his sonorous voice, with such remarks as "Long Live Poland! To your art! To your beauty!" To no great avail, as Tamara was not inclined to surrender so easily. She, the "little hot potato", who had already got through numerous lovers of both sexes, had chosen, for her part, to

Portrait of Tadeusz de Lempicki, ca. 1932
Pencil on yellow-brown paper, 22.8 × 15.9 cm
Wilmette, Illinois, J. Marion Gutnayer

Gabriele d'Annunzio, photograph with dedication to Tamara, 1926

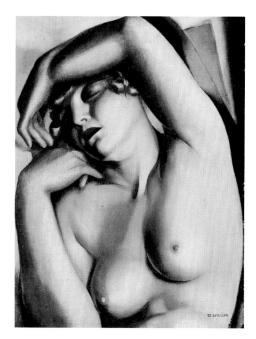

Sleeping Woman, 1930
Oil on wood, 35 × 27 cm
Private collection

Idyll, 1931
Oil on canvas, 41 × 32.5 cm
Private collection

play it coy. D'Annunzio, unused to such behaviour, thought her a "teaser", and was soon thinking of ways of getting rid of her, or at least that was what he told his housekeeper: "He cannot stand that Polish woman, he wishes ardently that she would leave. She would appear to be fickle, she would like to rouse him to passion (poor creature!), she also tells him that she is afraid of getting pregnant, being only twenty-seven years old – although she looks more like thirty-five; and that for fear of syphilis she has always held back from love affairs. 'You must understand, I have a young husband, and I'd rather not impose such a gift on him. You have so many women that I'm not sure whether I can trust you.' "[21]

It will be clear enough from this that Tamara was a capable exponent of litotes. The Commandante was outraged; he could not believe his ears. "This woman dares to say such a thing to me?!" Aelis rubbed salt into the wound: "I don't think that would occur to anyone unless she was on the game." And she added: "I think she accepts your gifts too readily; in two days you've given her more than 25,000 lire." "Yes," replied the Commandante, "I would have done better to give the money to charity."

But the "teaser" technique bore fruit. And the beauty, for her part, felt that she would benefit by softening a little. She "covered his face and neck in rouge." And then, one night, the blushing young fawn went so far as to allow him to caress her. And when he asked if he "might come", she replied, "Yes, but only with your clothes on." On hearing which, Aelis, the confidante, exclaimed: "Tell her to f—- off!" "Alas," said the old Adonis, "that's precisely what she won't do."

The fact that someone dared to resist him had nevertheless made an impression on the *comandante,* who, for his part, took his revenge with words that Tamara, for hers, received with a formal smile: "You're nothing but a little tart, not a lady at all – a high-class tart, I admit. It is only my sense of chivalry that prevents me from having my most menial servant show you the door. But I shall be gallant to the end; I shall do so for the sake of your husband, whom I can only pity for having landed in the talons of someone like you. I shall dine with you, but leave you early, because at half-past ten I am expecting a girl-friend who is to spend the night with me."

He treated her with contempt, speaking of the war, and of his fear of losing an arm: "Just think, for a writer ... And then I couldn't have given you a spanking ..." He also got her to take cocaine, exploiting the situation in order to "see her completely naked; I stroked her all over, and even rubbed my you know what up and down her splendid arm, as country barbers do when they sharpen their razors on a leather strop. But when I ventured a little further, wanting to take the matter to its conclusion, she seemed to pull herself together once more, saying: 'Why are you doing these nasty things to me?' "

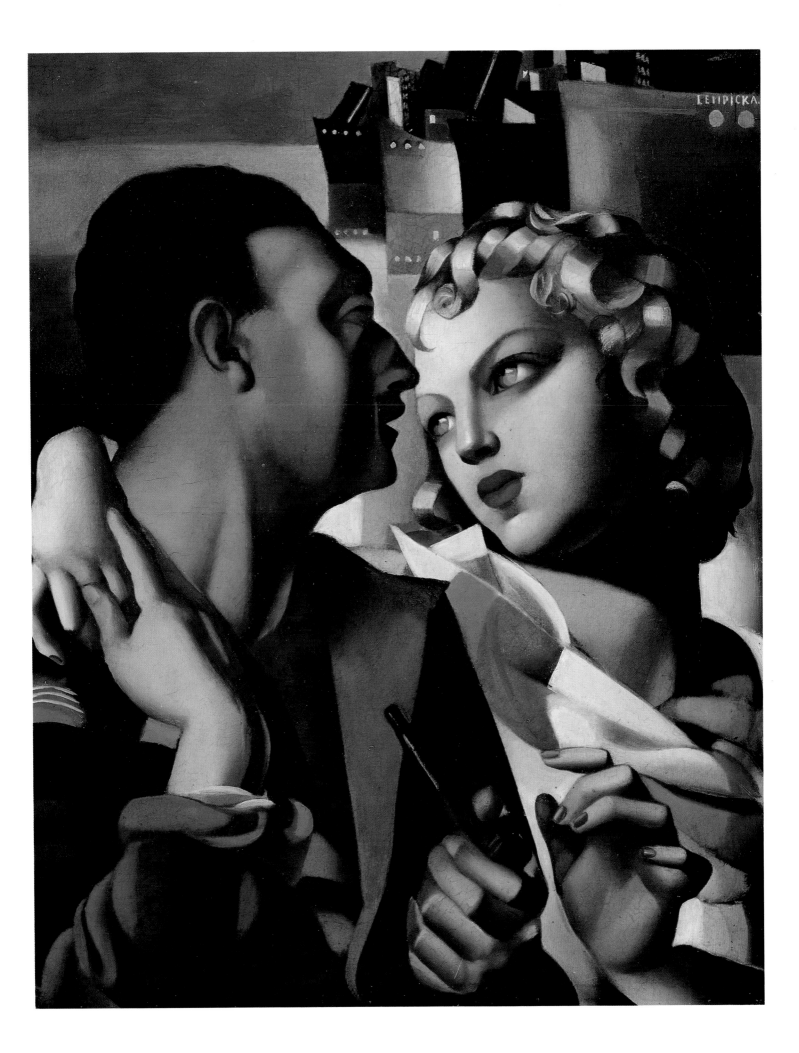

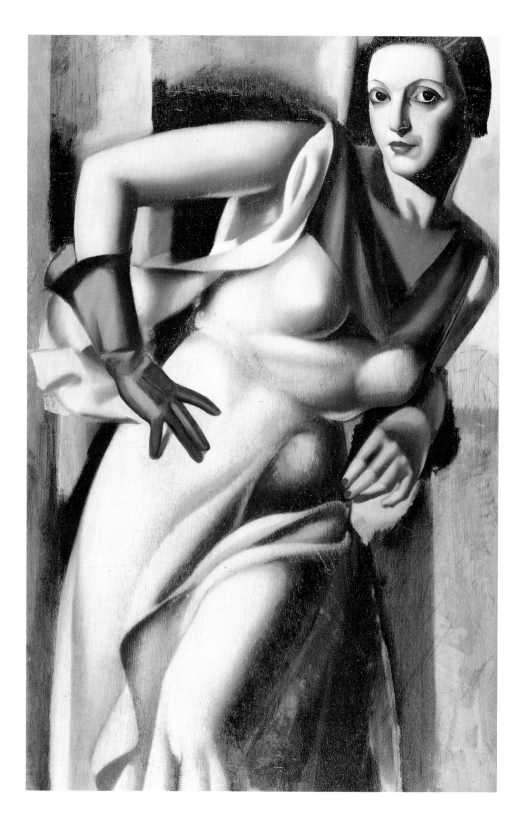

Lady with Green Glove
Oil on wood, 100 × 65 cm
Private collection

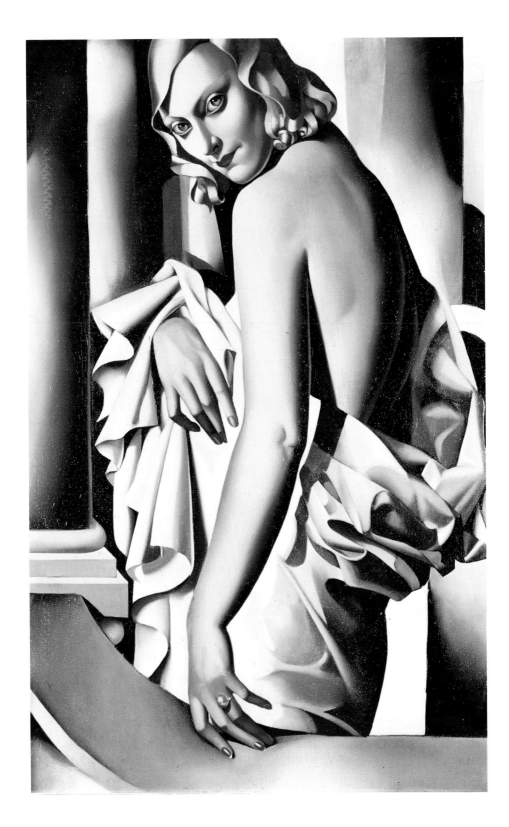

Portrait of Marjorie Ferry, 1932
Oil on canvas, 99 × 65 cm
Private collection

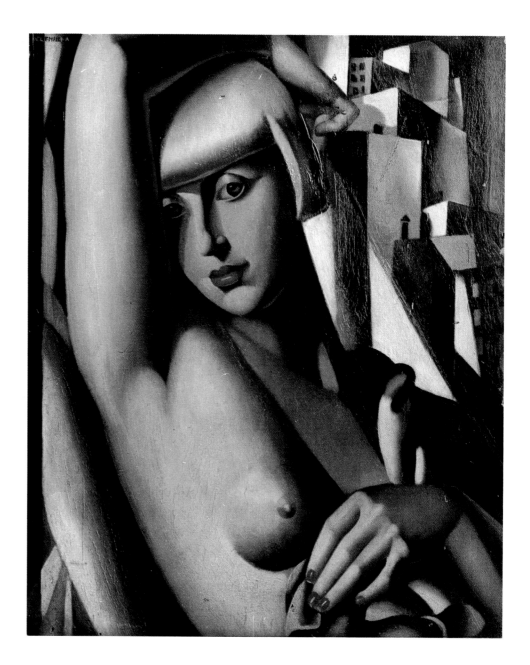

Portrait of Suzy Solidor, 1933
Oil on wood, 46 × 38 cm
Cagnes, Château-Musée

The comedy reached its climax when Tamara sent him a very sweet letter saying that she was expecting him. "As you may imagine," d'Annunzio confided in his housekeeper, "I was convinced that this time she would yield, and I had, as you see, even taken along the accessories for love-making (he showed me the little bag; A.M.); and I had spruced myself up accordingly. I found her more lucid than ever. She absolutely refused to have another pinch of cocaine, allegedly for fear of becoming addicted, as she had been a few years ago. Instead, she rubbed some into her gums – how can anyone be so idiotic?! I tried to make her submit, I took off my pyjamas to show her the beauty of my body, whereupon she turned away, saying that she found pornography disgusting. When I asked her what her intentions actually were, she started talking about the picture she wanted to paint, and said that perhaps I was avoiding mention of it because I didn't know her fee. Just imagine, Aelis, saying such a thing to me! All I could manage to say was: 'What,

Madame, do you think you can talk to Gabriele d'Annunzio like that. Well, then – adieu!' "

Now while the two protagonists were both extremely obstinate, they were nonetheless too civilized and too intelligent to turn this comedy into a drama. The farce thus ended in a draw, a dialogue of the deaf. Tamara was thinking only of her picture (which was never to see the light of day), while the *comandante* remained the unhappy captive of his carnal desires, lonely in the midst of his harem. But the affair between these two wild beasts still lacked a worthy and poetic conclusion. A few days later, a messenger rang at Tamara's door – she had meanwhile taken refuge with friends in Gardone – and presented her, according to Kizette, with a roll of vellum and a little jewelry case. Inscribed on the vellum was a poem by d'Annunzio, dedicated to "La Donna d'Oro", while the case contained an enormous topaz set in a solid silver ring which fitted the middle finger of her left hand exactly. The perfect little d'Annunzio touch ...

In her letter of reply, Tamara, by now on her way back to Paris, reminded the old lover of the words with which he had greeted her one morning during her stay at the Vittoriale: "I have spent a night in sorrow – thank you", and alluding thereto, replied that she "had been through hours of suffering – thank you".[22]

Kizette continues thus: "She probably always regretted not having painted his portrait. But in 1927 her career began its steep ascent, and she had no further need of d'Annunzio ... She never saw him again. But until her dying day she wore the topaz which he had given her."[23]

Was it temporary fatigue with men pursuing her like a bitch on heat, or a real desire to record her fantasies on canvas? No matter:

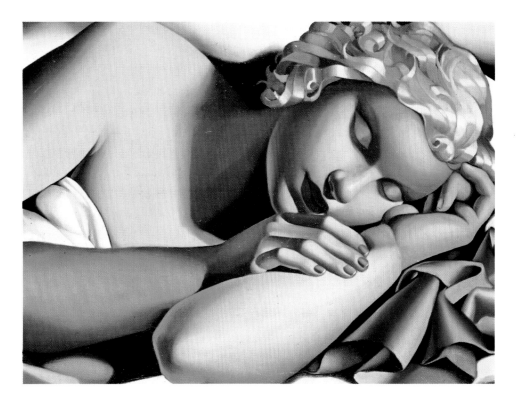

Sleeping Woman, 1935
Oil on canvas, 33 × 42 cm
Private collection

Leaf from Tamara's sketchbook in the 1920s
Pencil on paper, 23.6 × 15.6 cm
Private collection

"I wanted to paint an old man. It was an over-
whelming desire. He came with me into my stu-
dio ... Then, one day ... he took from his pocket a
yellowed newspaper cutting. It had already been
folded and unfolded a hundred times. He gave it
to me, saying: 'I was not always as you know me
now.' The cutting concerned Rodin's *Lovers*.
The names of the models were given. 'I am this
man,' he said."

Old Man with Guitar, 1935
Oil on canvas, 66 × 50 cm
Beauvais, Musée Départemental de l'Oise

whatever the case, Tamara now set about a woman-hunt of her own.
Her daughter Kizette has no hesitation in counting off the anec-
dotes. For example the one about Rafaela, the model for *Beautiful
Rafaela* (illus. p. 45), which the Sunday Times Magazine described
as "one of the most magnificent nudes of the century." She found
her in the street, and accosted her with the words: "Mademoiselle, I
am a painter. I should like you to sit for me. Do you accept?" And
the said Rafaela was so perplexed that she replied on the spot: "Yes,
why not?"[24] It goes without saying that Tamara only wanted to paint
her nude. She had her undress in her studio, and lie full length on a
sofa. The sittings and the affair were to last for over a year. For Ki-
zette, *Beautiful Rafaela* gives expression to the soul of Tamara de
Lempicka no less than does her famous *Autoportrait* (illus. p. 6),
and one of the reasons, no doubt, was Tamara's lust for her sitter,
for nowhere more than here does her hunger come so close to break-
ing the iron shackles of her technique. "The desire is palpable. She
lusted after this woman ..."

On another occasion, while at the theatre, she accosted another
woman whose profile had overwhelmed her with admiration. "I am
a painter. I am currently working on a large picture with five
figures. But I lack one, and that one is you. Would you care to sit
for me?" And her heart pounding, she added, "Nude?"[25] The lady ac-
cepted without hesitation, and came every day for three weeks to
pose in the nude. Following which, she disappeared without ever
having volunteered her identity. The only thing she said on leaving
was: "I knew and admired your pictures."[26]

When she was once painting an "Eve", holding in her hand an
apple no less round than her breast, she suddenly realized that she
needed an Adam to set her off (illus. p. 25). Once more she took to
the street to find him. Her choice fell upon a young and handsome
policeman, whom she persuaded to come up to her studio. "How
shall I pose?" – "Nude."[27] He took off his uniform, folded it up care-
fully, laid his revolver on top, and went to stand on the dais, where
he made the acquaintance of Eve and her apple. Kizette recalls how
her mother loved to relate this story.

There was henceforth no longer any room in Tamara's life for
poor Tadeusz, that "wet", that "failure", that "imbecile". In 1928
they divorced, and to mark the separation, Tamara left unfinished
the portrait she had started, meticulously omitting to paint the left
hand with the wedding ring, derisively entitling the picture – now in
the Centre Georges Pompidou – *Portrait of a Man (Incomplete)*
(illus. p. 50).

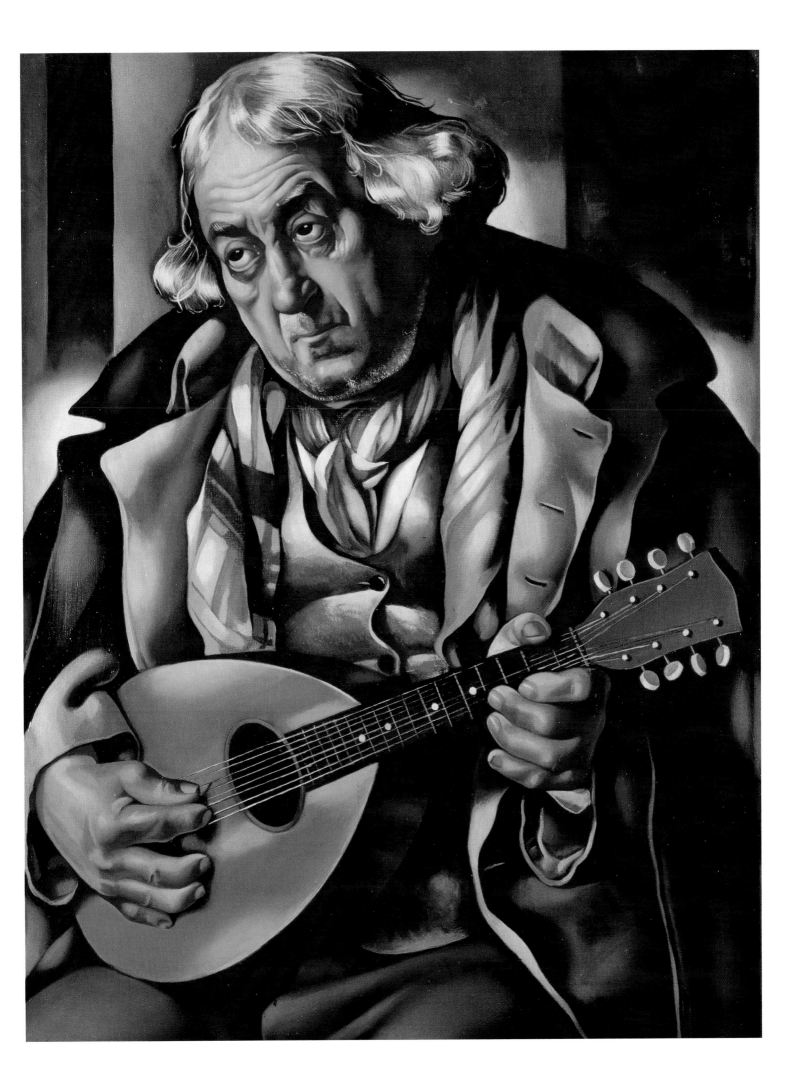

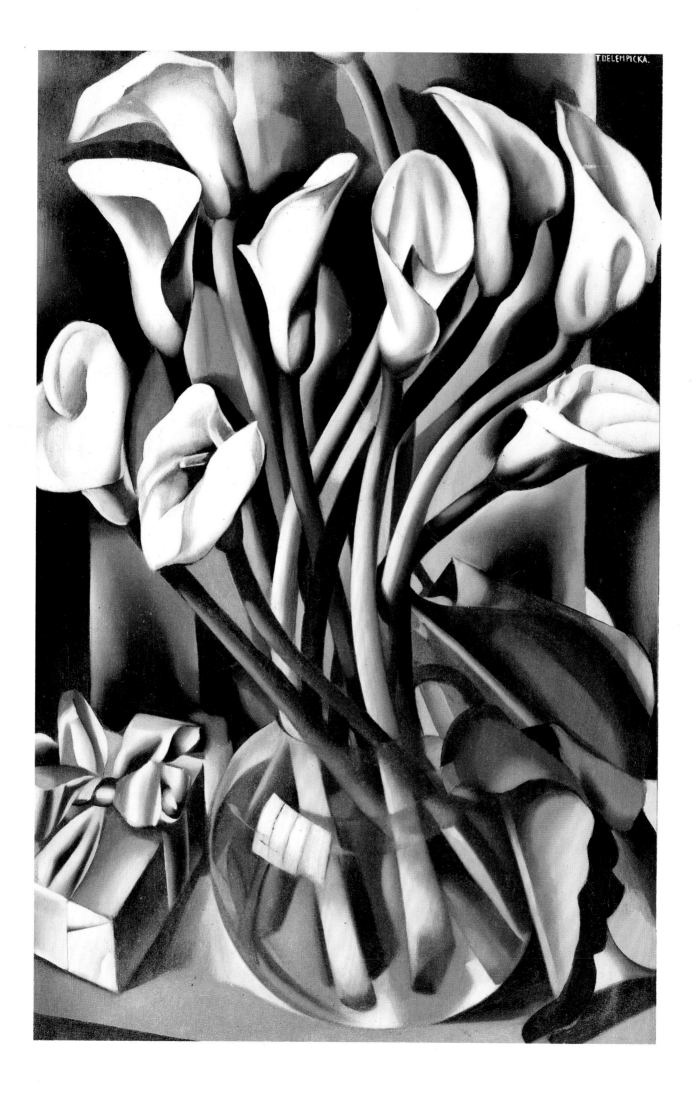

Success: money and a title

The first meeting with her second husband, Baron Raoul Kuffner, took place at a time when she was enjoying great success as an artist. The Baron, owner of vast estates in the Austro-Hungarian Empire and immensely rich, was also one of the major collectors and patrons of her work. He already owned a whole series of "Lempickas", when he commissioned from her a portrait of his mistress, the famous Andalusian dancer Nana de Herrera (illus. p. 36). Tamara found her extremely ugly, and decided that Kuffner's taste must be very poor. Not even as a nude model could the dancer manage to please her, and so she shrouded her in lace – à la Botticelli for his Venus in *Primavera* – in order better to bring out her nakedness. It is quite obvious that she hated this woman: she emphasizes her animal lubricity to the point of caricature. Not content with this, she later used Herrera for one of the "damned women" in her *Group of Four Nudes* (illus. p. 24), in which she is depicted as the most vulgar, primitive and lascivious of the whole group, the one most possessed by the demon. Concerning this picture, which was completed in 1929, a contemporary made the devastating comment that it was tantamount to murder; and not long afterwards Lempicka had replaced Herrera as the mistress of the highly cultured Baron Kuffner.

It was not until the then Baroness Kuffner died of leukemia in 1933 that the Baron was able to regularize the relationship by marrying Tamara, thus giving her everything which she had always craved, namely a title and a lot of money. The Baron enabled her to break out of her position on the fringe of society, and provided her with status. At last here was someone who could give her something to satisfy her hunger. One might note in passing that the baronial title had been conferred on the Kuffners – a family of stockbreeders and brewers – by Emperor Franz-Josef in recognition of their services as purveyors of produce to the Habsburg court.

By the time of her second marriage, Tamara's reputation as a painter among the cosmopolitan "nomenklatura" whom she frequented was higher than ever. People were fighting to be painted by Tamara de Lempicka, who, for her part, declined a large number of potential commissions, continuing to choose according to her own

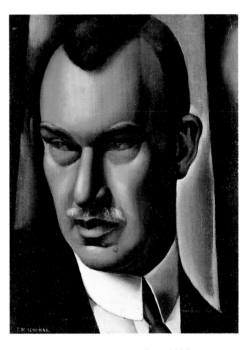

Portrait of a Man, Baron Kuffner, 1932
Oil on wood, 34.9 × 26.4 cm
Private collection

Calla Lily, 1941
Oil on wood, 91.5 × 59.7 cm
New York, Cresswell Mathysen-Gerst

Mother Superior, 1939
Oil on canvas, 22 × 27 cm
Nantes, Musée des Beaux-Arts

"In her face were reflected all the sufferings of the world; it looked so frightful, so sad, that I left again at once. I forgot why I had actually come. I knew only that I had to fetch my paintbrush and canvas and come straight away, to paint her, to paint this face."

criteria, her own fantasies, her own desires. One of her most assiduous collectors was Dr. Boucard (illus. p. 47), a scientist who had made a fortune from inventing the drug "lactéol". He would, for example, buy up a whole year's output of hers in advance. He also possessed one of the "unambiguously lesbian pictures" by Tamara, *Myrto, Two Women on a Couch*. He commissioned from her portraits of his wife (illus. p. 46), his daughter (illus. p. 39) and himself. The American millionaire Rufus Bush made a contract with her to paint his fiancée; she demanded a horrendous fee, but he paid it. This commission gave her the opportunity to discover America, and also to slip away for a whole month to New Mexico, where a "very rich and very attractive" stockbreeder kept a ranch.

Key and Hand, 1941
Oil on canvas, 36 × 48 cm
Private collection

Tamara's first stay in the United States co-incided with the Wall Street Crash. A first alarm signal, to be followed by others. Thus she remembers an incident while she was painting a portrait of King Alfonso of Spain. During an excursion to the countryside *à deux*, the painter and her illustrious sitter encountered a number of workers at a flour-mill complaining they were unemployed since their mill had been closed. "I am the King of Spain," replied His Majesty, "and I am also unemployed."[28]

Tamara's reminiscences from the period before the outbreak of war are marked by a chaos of images which gradually condensed into a kaleidoscope of horror. There is the scene, for example, which begins with a peaceful mountain walk in the Austrian Alps.

Surrealist Landscape
Oil on canvas, 34.3 × 26.7 cm
Private collection

Surrealist Hand
Oil on canvas, 69.2 × 49.8 cm
Private collection

New York, Studio at 322 East 57th Street, 1942–62

While she and the Baron were breakfasting on the hotel verandah, they noticed a group of blond youths marching along, singing: the Hitler Youth in all their splendour.

She had not spent all this time and effort amassing a fortune only to lose it immediately. There was only one solution, she declared to the Baron: sell up and emigrate to America. Kuffner, after long hesitation, eventually listened to what she was saying, to his great good fortune, it must be said. He sold the majority of his estates and sent his family heirlooms, jewelry and furniture to Switzerland. Just in time – in 1939 – they left the Old World, and thus began, thanks to the advice of his far-sighted consort, a lengthy holiday for two in the United States.

The fortune thus rescued came at a most opportune moment for Tamara. For not only was she, this superb specimen, this painter of the age, growing older – gradually and imperceptibly; the sources of inspiration and the art deco ingredients were losing their freshness, too. To be sure, seized by a sudden bout of humility, Tamara had already tried to renew the themes of her painting by, for example, taking an interest in the poor. And even in religion! Before setting out for America, in a fit of artistic depression, she had gone to a convent near Parma to seek new wells of inspiration. As she told Kizette: "I entered a wonderful Renaissance hall with columns and a high ceiling, where I found the Mother Superior. In her face were reflected all the sufferings of the world; it looked so frightful, so sad, that I left again at once. I forgot why I had actually come. I knew only that I had to fetch my brush and canvas straightaway, to paint her, to paint this face."[29]

The picture (illus. p. 64), on which she worked in New York for

Paris, Studio in rue Méchain; the *Portrait of Madame Boucard* can be seen on the easel, ca. 1931
(see illus. p. 46)

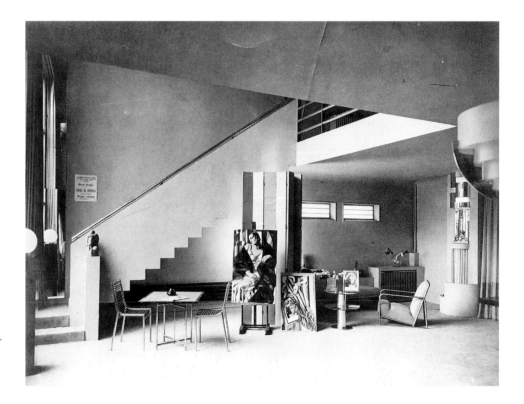

Lady in Yellow, undated
Oil on canvas, 78 × 118 cm
Private collection

three weeks, pleased her husband very much, but he was alone in his opinion. Very many critics, wrote Kizette, took quite the opposite view: "Although the *Mother Superior* was acquired by the French Republic in 1976, and now hangs in the Musée des Beaux-Arts in Nantes, there are many who consider it one of her worst paintings ..."[30]

Kizette's conclusion was harsh: "It turned out as Cocteau had predicted: her social life began to corrupt her art ... Once she set foot in New York, Tamara de Lempicka disappeared. What was left was a chic curiosity named Baroness Kuffner."[31]

For Tamara, the "baroness with the paintbrush", "Hollywood's favourite artist" as she soon became, there was only one thing left to do: end her career in beauty. And she was to do so in grandiose style. Her love for beautiful women, together with her love for successful "media coups", for example, united in her organizing a spectacular competition in the hope that it would attract as much attention as possible. The episode took place on America's West Coast, in California, in 1940. Tamara wanted to finish her *Susannah and the Elders*, an appendix, so to speak, of her *Susannah in the Bath*, a picture on everyone's lips at the time, as it was currently on show in New York and was being widely reproduced in the press. The win-

ner of the competition, which was open to female students of the University College of Los Angeles, was to be the model for this second Susannah. So who was to sit nude for the famous "baroness with the paintbrush"? No less than a hundred or so candidates presented themselves, and were invited into her studio for assessment. It was one Cecilia Meyer, a buxom beauty from American high society, who carried off the much-prized honour of being allowed to sit for Susannah. It was she, namely, who, both in her facial expression and in the suggestive curves of her young body, who most reminded Tamara of that first Susannah who had fascinated her so much, and who had been left behind in Europe. The baroness knew perfectly well how to obtain the maximum publicity for her artistic obsessions, in that she saw to it that the press was generously informed about her activities. Her attitude at this time has something of the Dalí about it, a Dalí who at this very moment was pacing the streets of New York, carrying a bell which he would ring whenever he thought he was not being given the attention that was his due. "The thought that I might not be recognized was intolerable ..." This confession by the master of the soft clocks – the Baroness could have chosen it as her own motto. Must not the dandy, in Baudelaire's words, live and sleep in front of his mirror? Which need not impair the working of those other mirrors: the pictures, the fans, the magazines ...

The baroness's more "virtuous" subjects are, it must be said, lacking in conviction when compared with the sophisticated and gallant works on which her former glory had been founded. Is not *Mother Superior* (illus. p. 64) found wanting when tried in the balance against, for example, *Suzy Solidor* (illus. p. 58) or *Beautiful Rafaela* (illus. p. 45)? Do not the honest faces of simple people, as for example in the portraits *Old Men*, *The Breton Woman* or *Young Dutch Girl* pale beside the Ingresque lasciviousness of such pictures as *Rhythm, Group of Four Nudes* (illus. p. 24), or *Andromeda* (illus. p. 27)?

The Orange Turban, 1945
Oil on canvas, 27 × 22 cm
Le Havre, Musée des Beaux-Arts

Amethyst, 1946
Oil on canvas, 77 × 64 cm
Geneva, Joseph Nehmad

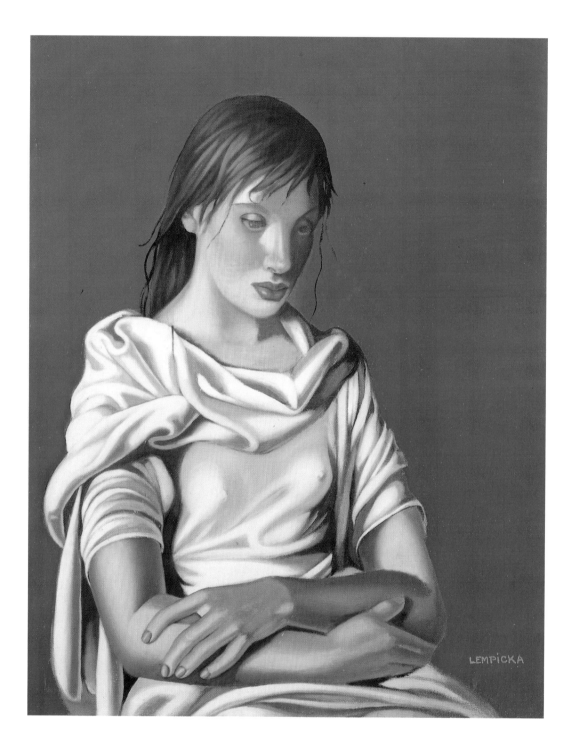

Lady in Blue, 1939
Oil on canvas, 50.8 × 40.6 cm
New York, The Metropolitan Museum of Art,
donated by Kizette de Lempicka-Foxhall, 1986

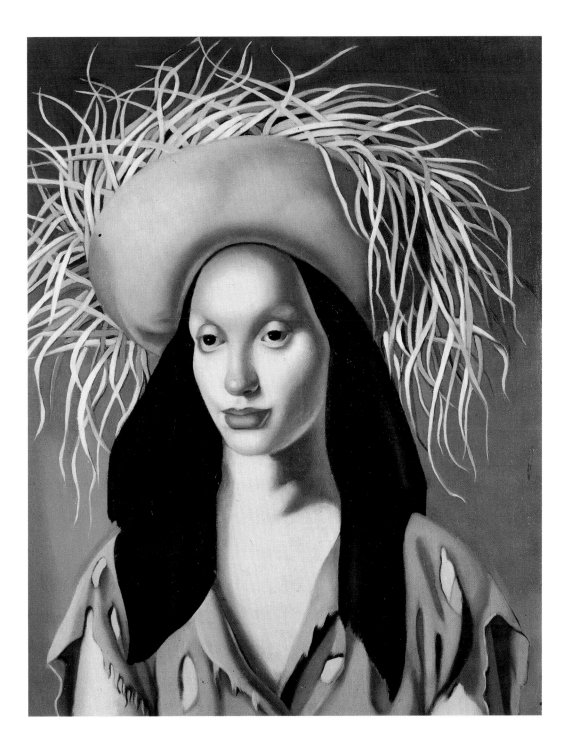

Mexican Girl, 1948
Technique and dimensions unknown
Private collection

"She is such fun, and her pictures are so amusing"

For all that, Tamara did not deviate from the course she had now set, continuing to associate with such Hollywood stars as Dolores del Rio, Tyrone Power and George Sanders, with her "poseur" friends, as the Baron called them. Occasionally she would hold an exhibition: for example at Julian Levy's in New York, or at the Courvoisier Galleries in San Francisco, or at the Milwaukee Institute of Art. She was rich, and she could afford what she wanted. The tabloid press no longer spoke of the painter who had become a baroness, but now churned out only the more noble version of the baroness who had discovered a talent for painting. The result was disastrous: while her image as the painter of the Roaring Twenties was gradually fading into nothingness, her image as the fashionably elegant society lady was coming more and more to the fore. In her memoirs Gloria Vanderbilt describes how she was helping her mother to prepare a party in Hollywood: "And don't forget to invite Baroness Tamara de Lempicka-Kuffner. She is such fun, and her pictures are so amusing."

Girl with Guitar, 1963
Oil on canvas, 61 × 79 cm
Private collection

"*She is such fun, and her pictures are so amusing*" – Kizette emphasizes the point: "No artist worthy of the name could imagine a worse epitaph."[32]

Tamara tried one last time to stage an artistic comeback. She tried once more to capture the spirit of the times as she had managed to do so brilliantly for the age of art deco. In order to explain the process, Kizette compares the fate of her mother with that of Mary Pickford or Gloria Swanson. These first stars of the silent screen – Mary Pickford was the first woman to earn a million dollars, Gloria Swanson the first to boast of spending such a sum – had both attempted to take the immense hurdle which the "talkies" represented. Likewise Tamara de Lempicka-Kuffner, the one-time "Grande Dame" of art deco, now that the wave of Abstract Art was sweeping all before it, believed that she could pick up this gauntlet and take the hurdle of non-representational painting.

Abstract Art, now triumphant across the board, renounced – by definition – all reference to any external model. Thus it represented the radical negation of all that Tamara had learned and hitherto pro-

Venice in the Rain, 1960
Oil on canvas, 66 × 91 cm
Hollywood, private collection

Tamara de Lempicka, 1951

Calla Lily, 1961
Oil on canvas, dimensions unknown
Private collection

duced in her work. But in an age when girls of good family would fill in the time between a tennis match and a piano lesson by painting a water-colour à la Kandinsky while listening to Wagner or Mozart, this seemed to her to be the only chance of survival as a painter.

Abstract Art, which had been invented in the prehistoric days of the turn of the century by such as Kandinsky, Mondrian and Malevich, had spread across the Atlantic, had indeed been forced across thanks to Messrs. Hitler and Stalin, who had driven many of its practitioners out of Europe. The movement had indeed unleashed a series of veritable civil wars, first between the "Geometrics" and the "Abstract Impressionists", and then between the adherents of Lyrical Abstraction and those of Abstract Expressionism, a typically American phenomenon, whose chief exponent was Jackson Pollock.

Between the "Geometrics" and the "Lyricists", Tamara had, of course, chosen the side of the former. But it was already too late. The Abstract movement gradually ran out of steam, soon to be replaced by Pop Art. These late works, which she produced both against her inclinations and against the current of the age, show absolutely no trace of the artistic vigour which had previously inspired and motivated her palette and her sable-hair brush.

Notwithstanding all her efforts to change the ingredients of her style, to dissolve the shapes, to blur the colours, her new pictures convinced nobody – probably they did not even convince her. When they were exhibited at the Iolas Gallery in New York in 1962, they were received by the critics with polite indifference, while buyers approached them with conspicuous reticence. That was more than Baroness Kuffner's pride could stand: the game was over, she didn't want to "play" any more; and she never exhibited her work again.

In 1980, Kizette fulfilled her mother's last wish by taking the ashes of Tamara de Lempicka up in a hired helicopter and scattering them into the crater of Mount Popocatépetl, that volcano in Mexico whose activity has never quite died down.

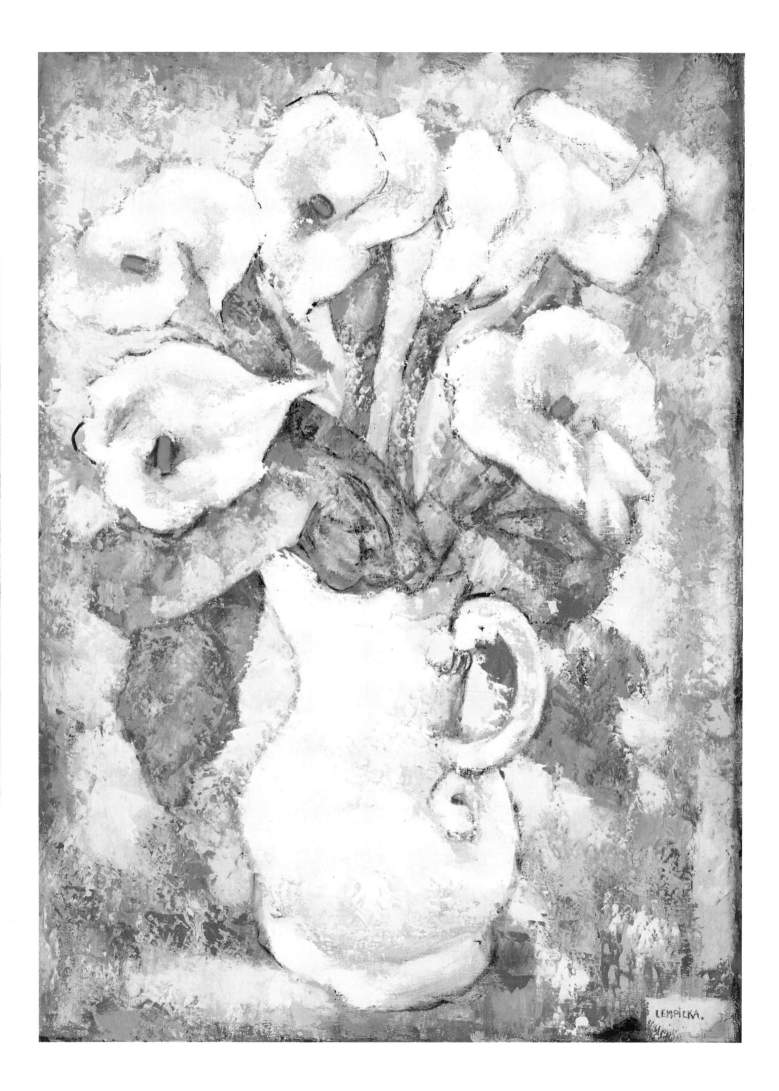

Tamara de Lempicka 1898–1980: Chronology

1898 Born Tamara Gorska in Warsaw, the daughter of wealthy parents. Her father, Boris Gorski, is attorney for a French trading company. Her mother, Malvina Gorska, née Decler, belonged to a well-to-do family, and had been educated abroad. Tamara has one elder brother, Stanczyk, and a younger sister, Adrienne. Tamara is a self-willed, domineering child, always the leader in games and the like.

1910 Tamara's mother commissions a portrait of her daughter from a famous painter who works in pastels. Tamara finds the sittings a torment and the end result unsatisfactory. Convinced that she can do better herself, she forces her sister to sit for her while she paints her portrait. She likes her own work better than that of the famous painter.

1911 Tamara is bored at school. She cleverly feigns illness, and thus succeeds in being taken out of school. Together with her grandmother, whose favourite she is and by whom she is spoiled, she travels to Italy, where she discovers her passionate love for art.

1914 In protest at her mother's second marriage, Tamara, by now at school in Lausanne, refuses to come home during the summer holidays. Instead, she stays with her Aunt Stefa in Petrograd. From then on, she is determined that the life of luxury she gets to know there will also be hers. Tamara falls in love with tall, dark, handsome Tadeusz Lempicki, a Petrograd attorney.

1916 Tamara Gorska and Tadeusz Lem-picki are married in the Chapel of the Knights of Malta in Petrograd.

1917–18 Notwithstanding the ghastly conditions being suffered by the mass of the Russian people, the Lempickis continue to live a life of luxury. Following the October Revolution, Tadeusz is arrested by the Cheka (secret police) in December. Tamara obtains his release through the good offices of the Swedish consul in Petrograd. Tadeusz follows his wife to Copenhagen. His period of imprisonment has made him moody and embittered.

1918–23 Tamara and Tadeusz emigrate to Paris, where Tadeusz is, however, unable to find work. Birth of their daughter Kizette. Tamara takes painting lessons, mainly from André Lhote, with

Tamara at the age of two, with her brother Stanczyk, Riga, 1900

Tamara in the 1930s

Tamara in the 1930s

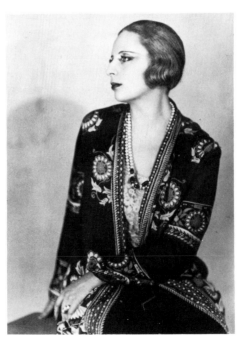

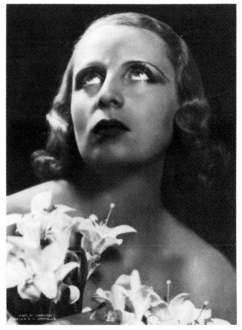

Tamara in the 1930s

the aim of making a living by selling her pictures. She paints still-lifes, as well as portraits of her daughter Kizette and her neighbour Ira P. The Gallerie Colette Weill sells her first paintings, and she thus makes contact with the Salon des Indépendants, the Salon d'Automne and the Salon des Moins de Trente Ans. This enables her to resume her life of luxury. She travels abroad, stays in the best hotels and surrounds herself with well-known writers and artists.

1925 The first Art Deco exhibition in Paris. Tamara makes a name for herself as an art deco artist, and exhibitions of her work are held at the Salon the Tuileries and the Salon des Femmes Peintres. American fashion magazines like *Harper's Bazaar* begin to notice her. Tamara and Kizette go to Italy, to study the classical masterpieces. Castelbarco organizes Tamara's first exhibition in Italy. Marquis Sommi Picenardi becomes her lover. Tamara meets Gabriele d'Annunzio, currently Europe's number one novelist, dramatist and lover. He takes it into his head to make her his next conquest.

1926–29 D'Annunzio commissions Tamara to paint his portrait, and she visits him at his famous villa Il Vittoriale in Gardone, purportedly to paint him, in fact however to start an affair with him. Neither the portrait nor the affair materialize. In 1927 *Kizette on the Balcony* wins the important first prize at the Exposition Internationale des Beaux-Arts in Bor-

deaux. In 1929 *Kizette's First Communion* wins the bronze medal at the Exposition Internationale in Poznan, Poland.

1928 After the bitterness of the preceding years, Tamara and Tadeusz divorce. The same year she meets Baron Raoul Kuffner, a collector of her works.

1929 She becomes Kuffner's mistress. She acquires a spacious apartment in the rue Méchain, Mallet-Stevens being commissioned for the interior decoration. Voyage to America.

1931–39 Tamara continues to work during the Great Depression; her works are exhibited in various Paris galleries.

1933 Baron Kuffner proposes marriage to Tamara, which she accepts on the advice of her mother. In view of the growing influence of the Nazis in Europe, her sense of insecurity increases, causing her throughout the nineteen-thirties to urge her husband to sell the greater part of his estates in Hungary.

1939 The pair take a extended holiday in America. The Paul Reinhart Gallery in Los Angeles puts on an exhibition exclusively devoted to Tamara's works. The Kuffners take up residence in Beverly Hills, where Tamara is active in collecting for war work.

1941–42 Kizette joins her mother and stepfather in America. Exclusive exhibi-

Tamara in the 1970s

Tamara in the 1930s

tions of her work at Julian Levy's in New York, at the Courvoisier Galleries in San Francisco and the Milwaukee Institute of Art. Tamara's artistic output, however, declines. Kizette marries the Texan geologist Harold Foxhall; they have two daughters.

1943 The Kuffners move to New York.

1960 Tamara changes her style to Abstract Art. She begins to work with a spatula.

1962 Raoul Kuffner dies of a heart attack. Tamara is deeply affected.

1963 Tamara moves to Houston to be near Kizette, who from now on manages her mother's affairs. Tamara dominates the family life of the Foxhalls.

1973 A retrospective of Tamara's works is held at the Galerie du Luxembourg in Paris.

1974 Tamara moves to Cuernavaca in Mexico. She makes frequent changes in her will, in order better to exercise control over her family.

1979 Death of Harold Foxhall. Kizette moves to Cuernavaca to care for her mother, who is now seriously ill.

1980 Tamara de Lempicka dies in her sleep on 18th March. Following her mother's wishes, Kizette scatters her ashes over the crater of Mt. Popocatépetl.

Notes

1 Baroness Kizette de Lempicka-Foxhall/
 Charles Phillips: Passion by design: the art
 and times of Tamara de Lempicka. Phaidon
 Press Ltd., Oxford 1987, p. 76
2 ibid. p. 76
3 ibid. p. 77
4 Franco Maria Ricci: Tamara de Lempicka.
 Franco Maria Ricci editore, Parma 1977,
 p. 13
5 ibid. p. 12
6 ibid. p. 24
7 ibid. p. 12
8 ibid. p. 11
9 ibid. p. 21
10 Baroness Kizette de Lempicka-Foxhall/
 Charles Phillips, op. cit., p. 40 f.
11 ibid. p. 41
12 ibid. p. 43
13 ibid. p. 53
14 ibid. p. 52 f.
15 ibid. p. 66
16 ibid. p. 17
17 ibid. p. 68
18 ibid. p. 68
19 ibid. p. 69 f.
20 ibid. p. 58
21 ibid. p. 70
22 ibid. p. 73
23 ibid. p. 73
24 ibid. p. 80
25 ibid. p. 81
26 ibid. p. 81
27 ibid. p. 82
28 ibid. p. 108
29 ibid. p. 127
30 ibid. p. 128
31 ibid. p. 129
32 ibid. p. 138

The publishers wish to thank first and fore-
most Baroness Kizette de Lempicka-Foxhall
for her kind and generous support, together
with her agent Wade Barnes. In addition, the
publishers hereby express their thanks to the
museums, galleries, collectors and institutions
listed hereunder for making this book
possible: Paris, Collection Alain Blondel, all
rights reserved: p. 7, 11, 51, 78 (centre and
right), 79; New York, Christie's: p. 24, 55, 66,
67; Munich, Galerie Wolfgang Ketterer:
p. 49; Wilhelm Maywald: p. 76; © R.M.N.:
p. 26, 34; Milan, Franco Maria Ricci Editore:
p. 6, 8, 12, 13, 14, 20, 21, 22, 23, 30, 36, 39,
42, 43, 46, 47, 54, 56, 57, 59, 63, 69; New
York, Sotheby's: p. 40, 48 (below), 62, 70.
The originals for all illustrations not listed
above are in the archives of Baroness Kizette
de Lempicka-Foxhall.

In this series: